The
SECRET
to great nail art

To my husband John, without your love, encouragement and wicked smile, I don't think this book would have ever been finished. My number one fan, my very bestest friend and my hero. Thank you for being you.

I would like to thank my online members and all those students who give me a reason to do what I do, you inspire me and help me be the creative person I am today, you make me smile every day.

Finally I would like to thank those special few who lend me your ear, when I am trying out something new or just have an idea I need to share. You're there when I need you and you're never far away when I don't. A special mention to Jane, without you in my life I would never have had the courage to release this book.

Sam Biddle

www.sambiddle.online : beinspired@sambiddle.co.uk
Cover Design by #MOMBOSS Digital Marketing Jenny Allen

Table of Contents

Dear Nail Artist

With the overwhelming choice of Nail art designs and application methods today, it is not hard to get lost in those pretty pictures on finger tips and ignore the fundamentals that will make your nail art stand out from the crowd.

In this book, I will teach you how to develop your ideas into something wearable, You will learn the theory behind colour, design and nail art itself in an easy and creative way. You will learn the skills to turn any inspiration into a nail art that sings and sells. This book is for people who suffer from nail art procrastination, nail art phobia, nail art avoidance and shiny object syndrome. Although I am not sure I can really help you with that last one.

As a renowned nail artist and educator, some say guru, I have made it my mission to share nail art with the nail world. To help nail technicians like you unleash your potential. To find the small bud of creativity and help you grow it into something which you can use within your work. Teaching online and face to face, I have been a nail technician and educator for over 16 years.

Nail technicians who suffer from nail art avoidance, all over the world, have already benefited from implementing the theory behind nail art, in this step by step guide. Every area of nail art is explained in a creative and visual way with exercises and examples.

Anthea Thomas says; "Following Sam's steps has pushed me further than I thought I would ever go with nail art, it has given me the confidence to take an idea and plan it, and then actually do it on nails. The information in this book has pushed my skills and has given me so many ideas for my own nail art that I would never have thought of. No other nail educator has done this and Sam truly cares about teaching her students how to unlock their potential".

I promise you that if you follow the simple steps and complete the exercises in this book your nail art will be amazing. You will understand the fundamentals of nail art which will give you the skills to develop your own style and niche in this area. You will

no longer need to copy other peoples designs and it will be you who will comes up with those unique looks.

Kay Gillespie says; "before I followed the theories in this book I thought I was ok at nail art, because everyone said how wonderful I was! But after following the simple steps Sam showed me my application of nail art has improved immensely. I have learnt the correct techniques and my confidence to do the artwork has grown so much, I'm no longer afraid to show what I can do and offer it to my clients. I am 50 years old and been doing nails for 3 years. Living proof that you are never to old to learn, Thank you for showing me a new way to approach nail art".

Don't wait to read this book, because you're going to miss out on something big. Nail art is a trend and right now it is big business. Cash in on the success and self expression nail art offers other nail techs around the world and build on your profit margin.
Don't be the nail tech in the dark about nail art, by learning as you earn you will be the kind of nail tech other people marvel at.

The nail art tips, tricks and theories you are about to read have been proven to create positive and long lasting results in your artwork, all you have to do to learn the secrets of becoming a sort after nail artist is to keep reading. Each chapter will give you new insight into the art of nails and help you go from inspiration to creativity. Take the step today to learn as you earn, complete the exercises and follow the steps and you will find your nail art is transformed into something that sells. Be Productive and Be Creative with each chapter and you will find the answers to make your nails the ones other people want to copy.

Sam Biddle
beinspired@sambiddle.co.uk
www.sambiddle.co.uk

I wrote this book, and then someone mentioned to me that I should give you a potted history of my own journey into the world of nail art, yes the 'how did you get to where you are' blurb. Those who know me and have attended any of my classes, will know my 'about me' speech is always something I struggle the most with, so here goes.

My name is Sam Biddle and I own and run two international companies Be Inspired which is all about education and self development and I also Co own Jealous Cow Ltd with my business partner Rebecca Orme, this is a product led company which offers unique and innovative products. For the past 17 years I have broken the industry rules time and time again. Playing with additives was once a rarity for a tech, and raised a few eye brows in the past, but 5 years ago I introduced my Be Inspired pigments. I hope I have shared with the industry that no matter how mad you think the idea is, try it, experiment and see what magic you can make.

I started in the nail industry quite by accident, I loved nails and nail art, and used to buy little kits from QVC. Do you remember those Spangles kits you could buy from United Beauty products. I would do my nails and my friends nails, and then word got around and their friends wanted a piece of the action. I needed to find the products wholesale so when I called it was suggested I needed to be a qualified Nail Technician and they signed me up on a course. Little did I know then in October 1999 that I would be hooked on nails and all things colour.

Starting out as a mobile technician I soon realised that in order to progress I would need a base, so I rented salon space for two years before taking the giant step of opening my own salon in Gillingham, Dorset with my husband John in 2002.

At 'Outside In Nail & Body Shop' we offered a wide range of treatments and had an immediate success on our hands. But just 4 months later my world crashed in when I was diagnosed with breast cancer. We had invested so much into our future we couldn't let it fail so I trained John in the art of nails before I went for treatment.

Looking back now I realise it took me a long time to recover; I came out of hospital and went back to work sooner that I should have. For me at the time, cancer was just a physical complication, I ignored the emotional and mental toll on my health. I continued to run the salon for another 4 years until 2006, when I sold it and took some time to recover.

In July 2007, with a fresh outlook and renewed enthusiasm I started Be Inspired. I wanted to provide learning and education for design nails that looked 'outside the box' but that could be incorporated into the brand that each individual nail technician knows and loves. I was an educator for EzFlow Nail Systems and I wanted to concentrate on my passion for teaching, not having the salon to divide my time I attended college to undertake my teaching certificate. I accepted an invitation to Kansas City to resit my Educator's status and join the American International Industries (AII) Global Team and became an International Educator.

I also retrained and became an IBD Elite Educator, I feel this has given me a wider knowledge and experience of other brands that I can pass on to my students. I enjoy both product lines very much and regularly use them in my own work. During my time as a member of the AII Global Team I was invited to speak at seminars and master classes at all the shows. I traveled nationally and internationally for AII Global, demonstrating, judging and holding seminars.

But then due to another illness I was forced to take some serious time off and I left EzFlow and AII to concentrate on recuperation.

I am going to jump back in time a little, because I want to talk about the competition circuit. I feel it is an important part of my journey, it is how I started in the fantastical world of extreme design. Whilst I ran the salon I entered my first competition in the pink and white category, not realising then just how much it would affect my career and help me develop my creative side.
As I sat next to another competitor I spent more time watching her develop fantasy nails on her model, and completely forgot the reason why I was there, I knew then and there that I had to give this a try! Motivated and inspired, I entered the Professional Nails competition in London the following September, winning 1st in the Photographic and 2nd in the Fantasy. I continued competing, and loved every second of it. I still miss it today. But once I was invited to judge competitions, I felt I could not do both.

Be Inspired was growing into an international success story, I developed four classes which would help technicians to find inspiration and express their creativity. I was the first Independent Educator in the UK and now, although we see a fair few around, I feel I still offer the industry something different through my education activities.

I ended up developing a very small product line and this was also born from necessity, Be Creative products are exactly what the nail market needed at the time, each individual product works well with whatever brand that a nail professional chooses to use, this then enables them to take their nail art skills to a different level, for example the nail art pen, pigments and gel paints help the nail professional develop and grow, the brand is versatile to encompass a range of application and techniques and work along side core brands already established in the market. The products and brand ethos encourage growth within their business

through innovation and inspiration to change.
But I am getting ahead of myself, at the time my small product line was growing and I was receiving a lot of interest from overseas. But my first love has always been for education. I needed some help and Rebecca Orme, who I had known and been working with for years, came to my rescue. Over a nightcap one night we began formulating a plan and three months later launched Jealous Cow Ltd - a parent company for a range of brands and activities that we would develop globally, the first of which was Be Creative.
Working with Rebecca has allowed me to continue to develop new and exciting products and educate worldwide.

I am still very strongly focused on art, design and creativity, anything with a bit of colour and glitter. If I am totally honest applying nails is a bi-product, it allows me to develop structure and controls the creative flow, it provides mini canvases with which to paint on and gives me the revenue to enjoy my job. But it is the art which keeps me going, this is a tough industry and

there is a lot of different elements at play today, which was not there just a few years ago. I want to continue to show nail professionals how to release their potential, my company name 'be inspired' was born from the feedback I would receive from my students ' you're an inspiration' or 'I am so inspired because of your workshop'. That is the essence of my motivation, to continue to inspire others and open their eyes to new possibilities and products. This also sets me apart from any one else, I have this need to share, help people grow and motivate them to think outside the box and try something new and spending time with nail techs and help them develop their own style and grow within their business.

My plans are to continue education, and refine it for those who want to push forward their skills. I am not affiliated with a core line brand, this way I can concentrate on the artistic side and not product application. I am not into sales or pushing a particular line.

The future of Be Inspired is ever evolving. With the launch of my online education program The Inspired online, I am hoping to bring a little learning to every nail tech's laptop, PC or iPad. Whilst you can't beat hands-on experience, and education in a class will still be the preferred method of learning for most nail professionals, it's not always possible to take the time out, or to afford the expense of travel and course fees. So we have to be creative and adaptable.

I am passionate about education, and want to give every nail tech the same opportunities I had to grow and learn.

My proudest moment was to have been nominated for services for the nail industry twice, winning industry innovator, also having been one of the finalist 3 years in a row for nail professional of the year. I am not competitive, and don't often participate in such awards, I just want to do what I love to do, and afford to continue to help and share with other like minded professionals. I give back to the industry where I can, judging nationally and internationally, and I am happy to offer free seminars and workshops at events and shows worldwide. I am not convinced I have shaped or changed the industry in any way, but I am content to believe I have affected it in a positive way, and hope to continue to see it develop and grow.

When I started this Journey, the last thing I thought I would be doing is influencing any part of this industry which I have come to know and love.

I have been fortunate to have worked with some amazing titles, from Cosmopolitan magazine and Woman to attending photo shoots and working with super models. Having a 4 page spread in the Independent and a centre spread in Daily Mail, featuring my extreme nail art designs, plus filming for Sky Living. There have been some pretty interesting experiences throughout my career and I am trying to remember them all, the highlights have to be my fantasy images being used for the 2012 Nailympia advertising campaign, My Nail Talk Radio interview USA, Being international judge for NailPro for three years in a row (2010-2012) and being invited as international judge for Nailympia 2013, 2015 and 2017. I have achieved front covers in numerous trade magazines and being a columnist in Scratch magazine and Professional nails.

Learning from my past and having had to confront my own mortality four times, I can look towards to a serene and harmonious future. The importance of family and well being are paramount. I feel deeply that this belief gives me the freedom to express myself.

There is never any dream or aspiration which can't be achieved, but you have to believe in your dream and hold on to what inspired that dream in the first place. Sometimes we forget that we need to be flexible in our thinking, along the way, you will have battles, hic ups and moments which down right throw you, but you need to have a clear mind at these moments and remember what it is you're trying to achieve. I hear a lot of people say I want to be like you, or have a career like yours, but they aren't telling me what they actually want, what is it that I do that they want? My advice to anyone, regardless of what you want to achieve is to have a clear idea of where you want to focus your attention within the industry, have a plan. Don't pick things out of the hat and think that will earn me money. My plan was always to be creative, to paint nails and work with colour, I wanted to somehow share this learning and educate. That is all that motivates me, and when I get an offer or opportunity or perhaps I am having a rough week when nothing seems to go right, it is remembering that plan that will re focus my attention to why I am doing this.

I am not interested in product distribution and sales, so I created a new company with the most amazing business partner who does want to do that. I like to travel, so I create opportunities to visit other countries and educate there, do you see where it is heading, you will end up with everything you want, but always come back to the thing which makes you happy, your initial dream. Your dream might not be education, it might be running a salon or a chain of salons, becoming a brand manager, distribution, session tech, head judge, beauty blogger the list is endless. Write down your hopes and wishes and outline your dream, this will remind you. With every twist and turn in your journey, every fork in the road you have to ask yourself will it take me to my dream.

CREATIVE THINKING

So you have learnt how to do nails and crafted a living from it, and now you have decided you want to hone your nail art skills and get creative. We all have an element of creativity within us, and it doesn't have to be with art. You can be a whizz with a flute or musical instrument, sing like Adele or be a culinary genius in kitchen. It doesn't matter how you express it, every human being is born with the ability to breathe life into something. To have the desire to make something beautiful and express yourself is quite normal, it doesn't matter how you do it or where your talents lie. You don't need to be artistic to be creative, the flair burns within us all and once the differentiation is made, it will be easier for you to tap into your creative thinking with confidence.

Now listen, just because you bought this book does not mean you have to be budding artist and be hanging your master pieces in the Tate any time soon. I am not expecting you to be exceptional at art in order to follow the steps in this book. However, to have any success with the exercises in the chapters that follow, you need to understand how creativity works and since you have peeked at the pages of this book, it tells me there is something inside you that wants to inspire others with your creativity. I am going to help you develop this and expand it into nail art which will not only help you spread the creative love but make some money doing it. But first we have to battle some of those Demons.

You are a Creative Person!

The next time you think, 'I can never come up with good ideas' remember this; We have the ability to come up with a countless number of useful ideas and innovative thoughts every day. You are brilliant. Yes, this is a fact and it is your life. The experiences you have had throughout it that make you brilliant. Your life is unique, full of obstacles and inspiration. Take some time to remember every situation you have encountered, every problem you have faced, and the countless solutions and creative ways you have come up with to solve them. Creativity is not only about finding solutions to problems or thinking up different ways to do things, there is so much more we do in our lives that stems from our creativity.

Look at things in a new perspective

You problem solve on a daily basis, your mind is constantly ticking over and find solutions to the next task in front of you to get it done efficiently and effectively. The moment you step out of bed your mind is finding the best way to navigate your morning routine; getting you to work on time and processing alternative routines to save time.

Getting up in the morning is a great example as we tend to do the same thing every day, but subconsciously there is a lot going on. If we paid attention, we would notice the ideas and thoughts in action, finding solutions so that your routine becomes more efficient. Hey, if you're like me you might actually be aware of the way your brain is looking at all the different angles, and if that is the case then your half way there. Because that is what creative thinking is all about, It makes us look at things from a new perspective.

We all do it, especially you since you picked up this book. It means sub-consciously you're brain is looking for new information on how to be creative. So lets start you off with your first exercise.

EXERCISE

Using a mundane daily task as an example, find a different way you could achieve the same result. Find something you do every day and look at how you can improve it. For one week try changing up your routine and vary your actions.

I want you to start listening to that creative voice inside you and pay attention. Start with something simple, I am not asking you to do anything different here. Just change the order you do something everyday, like getting out of bed earlier, instead of jumping in the shower right away go down and make a coffee first and read. Or maybe jump in the shower first and get ready before stepping foot in the kitchen. Whatever you do, think of new ways of doing it for these seven days. Listen to your creative voice and let it come out and play.

I would suggest you write down your results, this will not only hold you accountable, but when you look back on them at a later date you will notice the difference in how you think today and how you may look at things in the future.

WORD OF WARNING

Look at this exercise as a positive. Do not write in the column 'how did it improve your day' anything negative.

There is a game I play called the glad game, it is from a book I read when I was 12 called Pollyanna. She played the glad game and found something in everything to be glad about. Yes, even the washing up. If you look at this exercise as listening to your creative process then you should also consider the positive message it is giving you.

Your creative mind is finding a solution to your problem, even if you don't know you have one. This exercise is to help you listen to that creative voice and action on those solutions.

Later when you are aware of them you can pick and choose. But for now, come up with new ways of doing things mundane, and then find the positive outcome, however small and write it down.
trust me, this is all going to make sense.

WORKSHEET

	What did you change	How did it improve your day	Will you add it to your routine
DAY ONE			
DAY TWO			
DAY THREE			
DAY FOUR			
DAY FIVE			
DAY SIX			
DAY SEVEN			

Positive thinking

Creativity is a state of mind. Telling yourself or others "I'm not very creative," or "I can never come up with new or clever ideas," destroys that state of mind. Creative thinking requires positive thinking. Remember, it is about looking at things with a new perspective and finding a solution to a particular problem. If we look at designing nails, it is not about finding a design; we use 'inspiration' for that, but more about interpretation the design and finding a creative way to dilute it and use it effectively.

Inspiration

Inspiration is critical to creative thought. Without sudden flashes of inspiration, we might never arrive at creative solutions to difficult problems. Without the fresh insight that inspiration grants us, we might never see the bigger picture. Look at the exercise you completed in the previous chapter; it is proof to how your creative mind is inspired to come up with an alternative solution to a mundane routine.

What we see, hear, feel, taste, and touch influences our state of mind. A positive atmosphere contributes to a positive and creative state of mind. So, to be inspired in your work all you need to do is surround yourself with inspirational props. I will talk about this in more detail later on in the chapter, but first I need to highlight something important.

Do you ever hear that little voice in your head which is telling you, 'you can't do this" or, "you're not good enough"? Goodness, it might even be cheeky enough to say, 'who the hell do you think you are?". Sometimes you're good at ignoring it but other times it is so loud.

Most of the time that negative voice is at it's loudest when you're doing something new, when your about to make a change in your routine or creative thinking. Like this book for instance, I am sure you're probably now thinking, wasn't this meant to be a nail art book? Why am I looking at positive and negative self talk? Trust me, it will all become clear. This is the moment where you will understand exactly how to stop putting up the mental barriers and push through the fear of not being a good enough nail artist. This is necessary.

You see, we sometimes get stuck in the same old loop and having to do or think in a new way makes us nervous. It is just your mind playing tricks on you and the fear of the unknown taking hold of us and not allowing us to try it. By simply pushing forward, you will find the answers to those questions of how, what and why with each new step into that creative process.

There is something I want to share with you:

> *"Fear is not real. The only place that fear can exist is in our thoughts of the future. It is a product of our imagination, causing us to fear things that do not at present and may not ever exist. That is near insanity."* - Will Smith

I watched the film After Earth on a plane to Australia and as soon as Will Smith said those words, my blood ran cold. I was frantically trying to write them down on my phone, I needed to remember them. It was like he was talking right at me. At the time I had been travelling for work for three years and every time I set foot in the airport my mind would start with the "what ifs". It was an exhausting battle to quell those fears and push forward. Just a couple of years earlier I was paralysed with those fears, stuck at home and afraid to leave it. I literally could not leave the house unless I had someone with me. You see, my body had done the unthinkable and turned on itself. Having survived cancer and suffered for three years with inter-cranial hypertension which meant spending many many hours and days in hospital, a few too many operations later, my mind and emotions had had enough and shut down. It could not cope with the unpredictability of my body and my heath. Fear and paranoia had taken over I was frozen, stuck without my freedom. But just as the quote says, fear is just a product of our imagination, everything I worried about had not happened yet and, if I am honest, might never have happened.

My story is not unusual and it took a lot of will power and strength to stop being afraid. Even today I push forward doing something new, like writing this book, and trust the answers and solutions will come when I need them. This is what I want you to understand, I am asking you to trust your creative process without knowing all the answers, without seeing the designs that will come and without having the structure written out in front of you. That is the beauty of creativity, it flows with the inspiration around us and grows as you take action.

Be Inspired

The first step is to surround your self with positive inspiration which you can use in your art work. These sources of inspiration will be triggers in your mind, like popping candy or fireworks, setting off a chain reaction and helping you move towards the next goal. Magazines pages, junk mail, cereal boxes, wrapping paper and birthday cards to name a few are great ways to generate and stimulate new ideas. As well as what we see or hear, the scents, textures, and tastes experienced during our creative thinking time contribute to our creativity. Collecting whatever materials inspire you and give you ideas is a step towards finding a creative solution.

You need to store these ideas and the brain is not the place to do it. Creativity is a visual process and you need to see your inspiration for your brain to make the connections. Whether it's a folder, a notebook, or an entire filing cabinet; keep clippings, thumbnail sketches, junk mail, photos, and anything else that inspires you or gives you ideas. Pinterest is built for this, I have boards both hidden and public which lets me gather inspired images and ideas in one place. I have a folder on my desktop and an album in my phone as well. Don't just file it and forget it - go through the file get in the habit of making notes, outlines, sketches, or doodles.

Jot down or record all your thoughts, no matter how bizarre or wherever you are, some of your best ideas are said to come just before falling asleep! Keep a notebook at your bedside, in your hand bag, even in the loo so you will always be ready to write down ideas. Later on in the book I will show you how to organise this inspiration so you can call on it like a handy resource file.

Creativity takes practice. Your creativity is there within you all the time, but you must make a habit of using it. Through imagination and creativity, using the thoughts we have and how we process them to determine our quality of life is a powerful tool. As Albert Einstein said, *'Imagination is more important than knowledge'*. Every thought we have is a creative thought and the question is not whether we are creative or not. The question is whether we are aware of our powers of creativity and are we able to expand and use them purposefully.

Nail Art in a Nutshell

If you're anything like me, you get to this part of any non-fictional work book and sigh. This is generally the boring bit, filled with information you already kind of know or are probably not interested in. Especially if it starts with the words 'History of'.

Now, I can't promise you that this part of the book will be so riveting that you will come back to the chapter time and time again. However I can say that understanding the subject you want to master will give you the authority when you're speaking about it, sorry should I say selling it. Yes you do need to think about the end goal, and that is getting our works of art on your clients delicate digits. Just like Salvador Dali or Leonardo da Vinci - two of my favourite artists by the way - wanted to share their creativity with the world and give the viewers of their artwork a way to enjoy an expression of themselves.

Having the understanding of a subject will give you confidence in it and in turn in yourself. You know what, that is quite important, so I will repeat it again:

UNDERSTANDING = CONFIDENCE

Plus, if you have managed to get this far into the chapter there is going to be some actual education going on here too, some things you can implement right away into your business. So lets get started shall we?

What happened then.

Yes, you got me, I am going to talk about the past. Dare I say it I am going to tell you little, tiny bit about the history of Nail art. But read on, because we can learn a lot from the past.

Nail art is by no means a new trend, it has been around for thousands of years and every so often pokes its head up in the fashion world and makes an impact, each time becoming bolder and more expressive. Over the years history has shown us that painted nails create a statement about the wearers social status, how they feel, or to express their views. Traced back over 5000 years, the concept of coloured nails can be found in history when the Japanese and Italians first started adding colour to their nails. The Chinese also applied a lacquer made of flower petals, beeswax and gelatine. They painted the mixture onto the nails and left it overnight, which stained the nail plates and left them shiny - genius right? In India, Henna was used to stain the nail plates and this method of nail art and self expression spread throughout different cultures over the years.

The Chinese viewed colour very differently and the use of it to indicate wealth and social status. For royalty in China; (circa 600BC) the Chou dynasty wore gold or silver dust on their nails, adorned with precious stones and cloisonné designs. This was an ancient technique in China for decorating metal work with colour glass paste, not unlike the stained glass effects we see today with the semi transparent polishes available.

The Egyptians also used colour as a status symbol. Queen Nefertiti coloured her nails in red, the recognised colour of a higher rank and the lower you were down the social order the lighter and paler the nails became. Using henna and even blood to stain the finger tips, Cleopatra continued this 'trend' during her reign.

What is interesting is that the first recorded examples of actual nail art was in the 13th century by the Inca's who painted images of eagles on their nails. You didn't really think it all started in 1990 did you?

The 20th century really sees nail colours and art emerging as a fashion trend to stay, in 1917 women used to buff their nails with cake, paste or powder, or a Hyglo Nail polish which claimed to be long lasting and waterproof. However, it was in 1920 when things started to change for women wanting nail colour. Car paint....yes that is correct, those high gloss enamel paints inspired French make up artist, Michelle Manard, to adapt them to use on nails.

After playing around with the formula and developing a polish which was safe and long lasting, we can fast forward this part of the history lesson to 1932. Revlon was born and the very first commercial nail polish sold. It was around then that Beatrice Kaye, a manicurist at MGM Studios created the Luna manicure. She used a rosy red polish and left the Luna and free edge bare, the look has evolved over time, with some Luna's painted in contrasting colours. This look can be created in pinks and creams for a more demure feel, or funky in bright bold shades. Incorporating it in a traditional French or American manicure can highlight the natural beauty of the nails as well. The shape and depth of the Luna can vary to create an illusion of a slender nail plate. This manicure has not just been seen on the catwalk but has been re-invented over time, even by celebrities; Ditta Von Tease the burlesque dancer who revived this nail trend with her tips painted scarlet and white crescent moons.

But there is one thing we know today as nail artists; trends can influence the consumer market and demand for a particular treatment. Colour or nail art application can change history. Today we have the benefits of social media and new looks coming and going in a heart beat, but in the mid 20s woman all over the world were not influenced by celebrities and colours until the introduction of technicolour. Moviegoers where suddenly treated to the spectacular sight of beautiful woman like Rita Hayworth wearing vibrant shades of red on her lips and nails. Every woman wanted them and Revlon was ahead of the game. By the 1950s Scarlet nail polish and matching lipsticks where the rage.

By the 60s the focus moved away from the deeper shades and turned to paler pastel hues. The 70s brought more natural nail shades through Vogue with Mia Farrow and Farrah Fawcett. The nail history books tell us that it was at this time the french manicure was born, out of the need from the film industry wanting a neutral and healthy looking nail to show up on film and stand up against the different costume changes needed. So Jeff Pink from Orly set about and created the whiter looking tip and a beautifully healthy nail bed colour, so the camera and the catwalk came to love this combination. The French claimed that this white tipped trend made popular by Hollywood starlets was around in the 30s which is why the word french was added later by Jeff Pink in his account to make the manicure seem more stylish.

As the centuries wore on nail fashion continued to grow and nail colours began to communicate certain trends and sub cultures. For example, wearing black polish in 1970 was a cultural signifier, made popular by the punks and rock stars.
Now nail art has become more creative, and is linked to the changing trends and fashions. Polished fingers and toes are no longer an afterthought but a carefully considered accessory.

Nail Art is a hot new trend which can be done at home with a little know how and some of that season's newest colours, or in a salon to get an elaborate hand painted design. Either way nail art can be for everyone.

Nail art can be as simple as using colour effects to enhance nail shape or a clever use of the gloss and Matte top coats to give a simple textured effect.
The improvements in varnishes over the years means it is easier for us to create fantastic nail designs. Not only do we now have varnish which dries in a 60 seconds, we also

have polishes which create unusual effects like crackle glaze. The quality available of the polish now is superb because the demand has made it so. The bristles on brushes are perfect for the job and help you to apply the polish well, the bottles sit nicely in the hands and range of colours are up to the minute.

Today, nail polish has become a super star in its own right. Nail art finishes, textures and formulas, like the introduction of gel in the 00s means we have a choice like never before. We don't need to stain our nail plates with blood and leave them over night to colour like Cleopatra. Today, we can add pigments, scratch out designs in minutes, creating effects and designs which clients and friends will marvel at.

Moving Forward.

Trends, love them or hate them, they move us forward. If you follow me on social media you may have seen a couple of my rants about certain nail trends being revived by the press as a 'new thing' or the 'latest look'. It is very difficult to come up with a new look now as it seems everything has been done before. What we find is that a look will reinvent itself because it captures people's imagination at that particular time, and of course social media is on it right away.

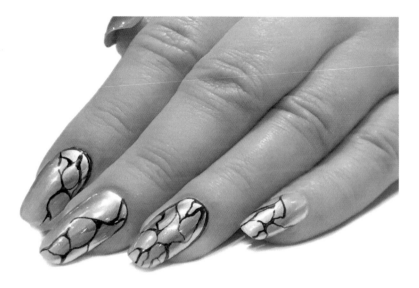

As I write this book, chrome nails are on every single social media timeline, however the application of pigment onto the nail plate to create a super shiny finish is not new. I had been applying pigments onto nails for over 5 years by the time this latest craze hit. In 2006 - 10 years ago - Minx launched with the fabulous silver plastic covering for nails which also had a reflection.

What it is important to learn here is that there is never a new 'thing' to hit the industry, just an 'improved' thing. That means someone has looked at a trend in the past and translated it into today's market.

Stepping away from Nails right now, look at the app Pokemon Go. I hope by the time you read this book it is still current and active. The app has revived an old game created by Satoshi Tajiri in 1995. Can you see how, by taking something and adding a spin to it, can influence the next generation and build on a brand new trend.

There is no such thing as original anymore, just reinvention. So much has been done before, all we can do to improve and re-evolve a product, idea or concept to suit our lifestyle today. Look back at how nail enamel evolved from car paint. Colouring nails was not a new thing, but how we coloured them to suit our lifestyle was.

We can do this with nail art as well. Don't sit and wonder how you are going to produce the next original look, this is why we use inspiration to help us take something we have seen and transform it creatively into something else.

Let us look at the french manicure and the introduction of the baby boomer look as an example. Instead of the hard line of contrast between pink and white along the smile line, woman want a look which is softer and gentle. So an ombre or a blend of the natural white and pink was created. A brand new look? NO. A reinvented look? Yes!

Traditionally done in acrylic, the baby boomer nail look can also be achieved in gel polish as well. But I introduced another new application method in June 2016 which makes achieving this look easier and quicker. Ahhhhhhh those magic words we salon owners and jobbing techs like to hear; easy & quick.

Does that mean my creation is anything less because it has been done before? No the application is the reinvention not the look. What I am trying to help you see is that your art work will always be another take on something else, and this is ok. This is how it is meant to be. You don't need to come up with the latest look and the newest trend.

Before we come to the end of this chapter I have another exercise for you. We spoke about the history of nails and the changing trends. Over the next few weeks you should take a tip or even a hand if you have time and try the different trends in the list at the end of the chapter. If you're not sure what they are then you need to do some research and google them. To start you off I have given you my step by step on how to do the Pigment Baby boomer nails. Once you have tried the different trends and have them in front of you as an example, I want you to change them up a little, try them with different products, different colours, add a new dimension or even blend a couple of trends together. In other words make them your own. Check out the worksheet at the end of the chapter to find out more and why you should be doing this.

Baby Boomer

I am not sure why this 'look' is called Baby Boomer nails, I much prefer French Ombre. I did try and find out but there is little on a Google search about them. My surmise after some investigation is that during the baby boom, women mainly wore bright red polish and frosted pinks and whites. But if I was marketing this look out, I would call them a French Ombre. it sounds prettier and more delicate.

Traditionally this look is done with acrylic and is not as easy as it looks, but you can get this look on a natural nail using gel polish and some perfectly pink pigments. if you would like to find the pigments used to create this look visit www.sambiddle.co.uk.

 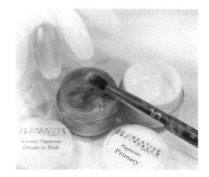

Step 1. Prep and gel polish your nails - I use white but you can use a pale pink if you prefer.

Step 2. Apply the pink which best suits your clients skin tone. be creative have two different pinks, a darker one with a yellow base in the pretty pigment collection and a brighter pink in the serenity, both are close to a skin tone, and both have a beautiful fronted shimmer to it.

Step 3. Now using the white from the Primary collection, taking some powder and working it into the brush first before adding it to the nail tip, work up towards and over the join. Now just top coat.

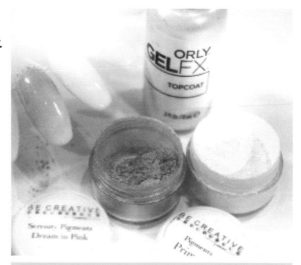

The pigment colours I have used are;
Pretty in Pink from the Pretty Collection.
Dream in pink from the serenity collection
White from the primary collection

WORKSHEET

Changing Trends

The reason why it is important to understand and try out the look yourself is to start getting that creativity flowing. Looking at an image of these trends is sometimes not enough, our mind might have the ideas but when we come to do it practically we need to learn how the original look was done, feel the flow of it and look at it in front of us.

So in this exercise you should look at the list below and recreate each of the look's, then once you have created the original look, create an updated version, your own version of this look.

Once you have actually copied each you will find the ideas on how to improve it will come to you easier, try not to think of those ideas until you have completed the original version.

This is a practical exercise and I really would advise you do this. Come back to it over the next coming weeks and complete the list. If nothing else you will have some more designs for your clients to choose from.

TREND	original	your version	notes on improvements
LUNA MANICURE			
LABOUTIN MANICURE			
BABY BOOMER			
CHROME NAILS			
2 COLOUR OMBRE			
NEGATIVE SPACE			
DOTS			

Dirty Sexy Thing

Creating an Ombre can be done using just cling film and an ordinary bathroom sponge as well, just in case you don't have pigments to hand.

I created these nails for super model Erin Oconner on a recent makeup shoot for Because London. This method not only makes your nails look longer but is so quick you can apply it over exising varnish to jazz it up before a night out.

1. Prepare the natural nails, apply your base coat and varnish. I am using the mineral FX collection from Orly.

2. Using cling film which I have gathered into a ball and applied some dark pink varnish, gently dab over the tip of the nail. This creates a junky broken application .

3. To create more depth in this design and a softer look, using a dark chocolate brown or even black if you are brave, dab this over the very tip of the nail.

4. Finally apply a top coat, this brings all the layers together and blends the looks beautifully.

Colour Theory

Whats that, I hear you cry? 'I don't know about colour theory!' I admit, as an artist I will nod my head and pretend I know all about colour theory and what goes with what. But alas this is not the truth and I completely understand. I am instinctive when it comes to applying colour, I just allow my creativity to flow and let it come from within, but that doesn't work for everyone I know. Just having the knowledge under your belt and understanding how it works can give you that magic formula I spoke about in Chapter two:

UNDERSTANDING = CONFIDENCE

The nice things about theories and rules is that they can be broken. But the most effective way to break a rule is to learn the rule first.

Colour theory is actually a simple formulation of combining colours that work well together 'in harmony'. It is a set of principles using a colour wheel to give you a visual reference.

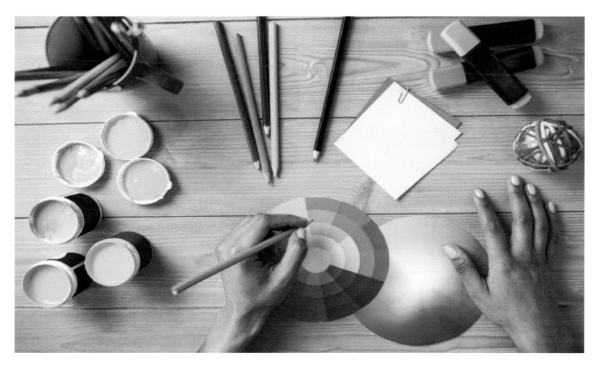

According to this theory, these combinations use any two colours opposite each other on the colour wheel, any three colours equally spaced around the wheel to form a triangle, or any four colours to form a rectangle. Any of these colour combinations are called colour schemes and will remain harmonious regardless of the rotation angle.

Colour theory only looks at the relationships of pure colours; it does not take colour lightness and saturation into account. While the shades may vary in your chosen colour scheme, you can use any tints, shades, and tones of the colour you have, colour theory pays attention only to the hue component.

My advice is if you're going for three colours, keep the shades the same, all bright, all pastel for example, to make the nail less busy.

So we have covered the science bit, lets get busy and start using this theory to our advantage.

So lets talk about Colour Mixing

The basic principles go like this.

 Your Primary colours are;

Blue, Yellow and Red.

 From these three colour you can mix any other colour these are called your **Secondary colours.**

 Mixing a secondary colour with a primary will give you a **Tertiary colour**

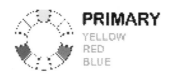 **PRIMARY**
YELLOW
RED
BLUE

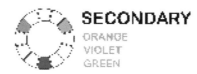 **SECONDARY**
ORANGE
VIOLET
GREEN

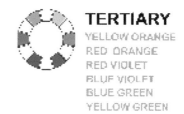 **TERTIARY**
YELLOW ORANGE
RED ORANGE
RED VIOLET
BLUE VIOLET
BLUE GREEN
YELLOW GREEN

The exact shade or hue of the secondary colour will depend on which red, blue or yellow you have mixed, and what quantities you have used giving you, in essence, a very extensive pallet.

But What About Black and White?

Black and white are not classed as a primary although like red, blue and yellow they can't be made by mixing together other colours. Black and white aren't used to create any colour and therefore excluded from the colour mixing theory. They only lighten and darken your colour palette. If you add white to a colour you lighten it and if you add black you darken it.

Creating Harmony

The colour theory is taught at school, and something which as an artist is ingrained in us, but how do we pick the colours we need to make a harmonious nail design?

First, let's look at what that means; What is a harmonious design? It is a nail design which is balanced and pleasing to the eye. I always say 'does the nail sing'? Does your nail designs engage the viewer and create an inner sense of order and balance.

Colour Combinations

It is important to create a harmonious balance of colours on your nails. When something is not harmonious, it's either boring or chaotic. The human brain will reject under-stimulating information - in other words boring nails or nails so overdone and chaotic that the viewer can't stand to look at it. The human brain rejects what it can't organise and what it can't understand.

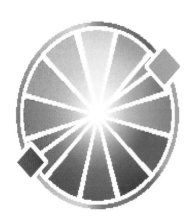

Check out this colour wheel and choose a colour. The two colours on either side of this colour will reinforce your colour and give you more scope. The colour directly opposite your chosen colour will compliment it.

These opposing colours create maximum contrast and maximum stability to your design, it really is that simple!

EXERCISE

In this quick exercise below, I want you to actually choose a colour and write it down in the column marked 'MY COLOUR'. Now follow the headings in this table, choose colours to reinforce your chosen colour, to compliment it and one which will clash. I have done one for you to start you off.

MY COLOUR	REINFORCE MY COLOUR	COMPLIMENT MY COLOUR	Colour not in Harmony
orange	*yellow*	*pale blue*	*dark purple*

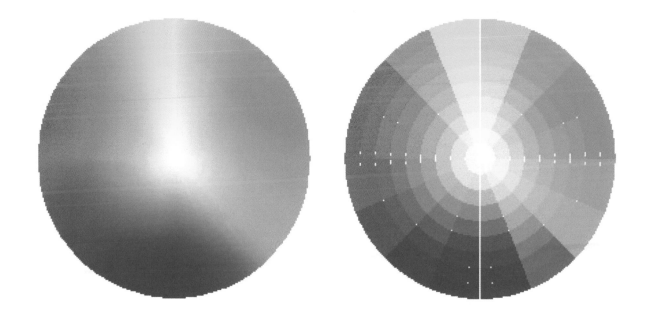

Hues, Shades, Tints & Tones

Colour theory only looks at the relationships of pure colours; it does not take colour lightness and saturation into account. While the shades may vary, for nail design try and keep the colour combinations in your chosen colour scheme to one tint, shade or tone. A lot of us use the terms hue, tint, tone and shade when referring to colour in art, but did you know each of these terms has a very specific meaning?

HUE
Hue is a term that seems more complicated than it is. A hue is just a colour. More specifically, a hue is any colour on the colour wheel.

TINT
Tints are created when you add white to any hue on the colour wheel. This will lighten and de-saturate the hue, making it less intense. Tints are often referred to as pastel colours, and many feel they are calmer, quieter colours.

TONE
Tones are created when you add both black and white to a hue. You could also say grey has been added. Depending on the proportions of black, white and the original hue used, tones can be darker or lighter than the original hue, and will also appear less saturated or intense than the original hue.

SHADE
Shades are created when only black is added to a hue. This results in a rich, often more intense and darker colour. Because of the overpowering nature of many black pigments, adding black to a hue is a tricky and sometimes frustrating exercise when mixing paint. Many blacks will change the character of a hue even in small amounts, so they should be used sparingly. Alternatively, a hue can often be made darker by adding another dark hue rather than black.

Don't be afraid to colour mix and build up your pallet with different shades and tints. Combine two primaries to make a secondary and add white. See what happens. Mix together a secondary and a primary to create a new colour. It is important to play around and experiment with colour, build on the knowledge and become comfortable the more you understand this theory.

The real theory behind colour and how it effects us.

Now there is so much more to colour theory than I have shared with you in this chapter so far. But it is not just about the theory, it is about understanding why colour is so important in our lives and by mastering it you will be able to use this theory in your business and attract clients.

People see colour before they see anything else, our minds are programmed to respond to colour. For example, we stop at red traffic lights and go on green. Colour offers an instant way of conveying a meaning, message or mood without words. There is research which tells us that 60% of the time people will decide if they are attracted to something, or not, based on colour alone.

People will make a subconscious judgment about a person, environment, or product within 90 seconds of initial viewing and between 62% and 90% of that assessment is based on colour and colour combination. It is amazing what our minds process in the blink of an eye, so making sure your colour choice and combination is in harmony is essential to getting your art spot on.

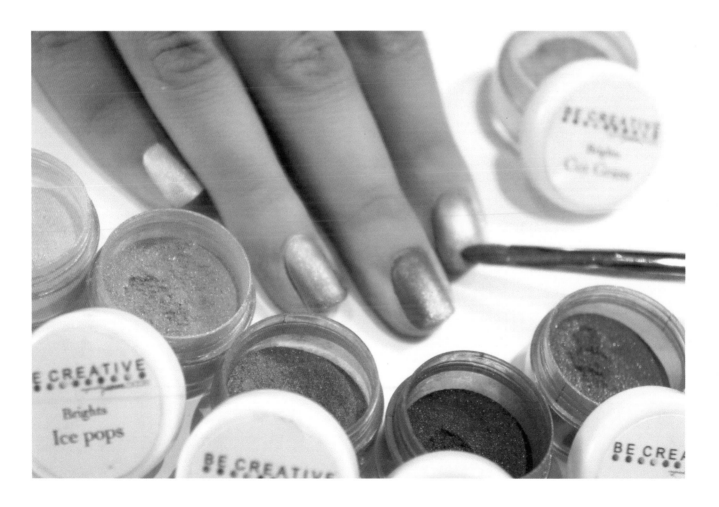

The Principles of Being Creative

This chapter will help you deliver your nail art in a way which makes sense, in other words your nail art will have some formation and structure which will give it harmony. Remember I told you I would help you make your nails sing? Before I go into those should and shouldn'ts about nail art and the design theory, let me ask you a question.

Are you a good nail artist?

Of course I hope your answer was yes, because it is easy to be a good nail artist, it just takes a couple of compatible colours, a few dots and lines and Boom, you have a decent looking nail which your client will be pleased with.

But to be a great nail artist that takes skill. It takes practice and knowledge of your influences, your products and a little creativity sprinkled in there too. But, it is not all about practical application. Before we go down the road of what, where and when you should place a stripe or add glitter, let me just give you a list of 'notes to self'. A check list if you like of eight things you should NOT do during the process of doing nail art. Print it out and keep it at your nail desk, until it is ingrained.

I have done a DO NOT DO THIS list because I think, as creatives, we are very aware of what we do, and have a preset towards the negative and doubt. Recognising the things we do and trying to change these habits of a life time is just the start of the design process. The biggest mistake artists and creatives can make is letting fear hold you back, and not trust ourselves to be creative.

SIDE NOTE
I did not go for a positive list, because it will be just another list of all the things you should be doing and you can't relate, because you're not doing them right now. So this list highlights the potential trip wires which you might find during the design and creative process.

Notes to self, when starting with your nail designs.

Don't think, just do. When we start listening to Doubting Della in our head we stop that creative process. Let your intuition and fingers take over

Don't over analyse your nail design. Sometimes we get stuck over thinking our designs and before we know it we have given up before we have started. You might think it will be too difficult, or you're not talented enough to pull it off. Don't let it stop you; it will be what it will be when you're done.

Don't be afraid to make a mistake. There is no right and wrong way, you have to believe that in art you can't make any mistakes. Make those mistakes, sometimes the best results are born from one.

Don't pile on the pressure. We are very good at this, and put ourselves under imaginary pressure. You're not going to win any prizes, or face the firing squad when your done with the nail, so no pressure there.

Don't care about other peoples opinions. Never do nail art for other people, do it for yourself. That inner creative genius will shine through, but if you're thinking about all the other creative genius' out there, then doubt and fear will take over. They don't care about what you're doing, so why should you care about what they might or might not think.

Don't rush anything. My problem is I get so excited about a design that I try and finish the nail before you have even started it because I want to see the finished product. This rush will show in your end results. I see it all the time in the online members when they post for feedback, and I tell them 'you rushed this nail'. They are always amazed how I can see that. Well if I can see it, so can your clients.

Don't copy. It will kill your own creativity and style. Don't take an idea from someone else and recreate it exactly. If you are unique and original you will have a style, this is what will define your work, not the actual pictorial designs. Concentrate on developing your style and what ever you use to influence your work.

Don't compare. Stop looking at other nail technicians and judging their talents against your own. We just have to face it there is always going to be someone else more talented than you, it might be that they seem to be more creative than you feel, or display a unique talent that you covet. But equally there will always be those who compare their skills with you. The time and energy you use up comparing your skills with other people, letting doubt and envy into your mind will slowly stunt your nail art growth. You're better off spending that time and energy on your own art.

Design Theory

Now that we know what we shouldn't be thinking, feeling and doing, lets learn something about design. Believe it or not there are some basic rules when it comes to laying down a nail design, most of them you probably do instinctively, However being conscious of them and implementing these principles will mean your nails will sing, instead of shout! These simple steps will take your nails from being ordinary to reaching the high notes!

Vertical verses Horizontal

Keep the direction of your design running from cuticle to tip and not side wall to side wall, this will make your nails seem longer, slimmer and down right sexy.
I have given you stripes here as an example but placing your design from cuticle to tip and not side wall to side wall regardless of what it iswill help make thoese nails more flattering.

Don't over complicate

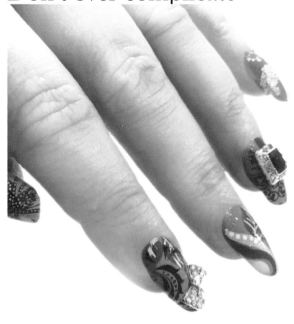

Use the 'less is more' principle, otherwise the design and colour choice gets over whelming. Adding more than 3 colours to any design is just plain torture to the eye. I am not talking about white and black; they don't count in your three. Also, keep the actual design elements uncluttered and delicate, not something which should belong in The Tate Modern (unless thats what you're going for)

The Harmony of your Design.

As I said before use a max of three colours in your design and add white or black to the combination for a harmonious look. Ideally use one colour and vary the shade from light to dark, but make sure you know your colour theory if you're adding additional colours. The harmony of your nail will depend on the colour combination.

Dark Verses Light

Keep the darker parts of your design towards the edges of the nail, at the tip or the cuticle area. Don't add the dark colour to the centre of the design, this will not allow the eye to travel over the nail. I call it the black hole theory, if you sandwich a dark shade in the middle of the nail, the eye will stop at the dark point, and get lost in the 'blob' they see. The nails will look chunkier and the design elements disappear in the black hole.

SIDE NOTE
Don't forget the golden rule, if you understand a rule then you can break it effectively. Don't think that every design should sit within these rules, these are the basic principles and a starting point. Master these then see where it takes you when you bend them little bit.

A Nail Art manicure for every occasion

I became a nail technician in 1999 and way back then the only type of nail art was over all 10 fingers and they all pretty much looked the same. I started creating designs over all ten nails which told a story, instead of each tiny canvas being individual, all ten became one, and the design flowed from nail to nail. If I am honest with you, I only wanted to become a nail technician because of the nail art, and adding pictures onto peoples finger tips all day long sounded perfect. But reality doesn't work that way, and we have time, money and taste to consider. Those clients have to pay for the nail art, sit there and have it done and then live with it for a few weeks.

As a creative, I and so many other nail artists before me, reduced the number of nails they would work on, and simplified the art work, creating a wearable salon viable (this means it can be done on a client quickly and be cost effective) nail which can be charged.

Now with social media ever present and the virtual conversation across the world, we have names for these nail art applications. They have become 'new' trends and a look to have.

This is a wonderful thing for the industry with the media reporting on celebrities sporting a 'ring finger manicure' and exposing the new 'bling pinkie'. Clients are now walking through the doors and asking for it, the nail art selling itself.

But let me clarify, I am not talking about the different designs and common applications like Ombre's and negative space, this will come later, right now we are looking at putting these looks together into a wearable and attractive package which will sell.

Combined look

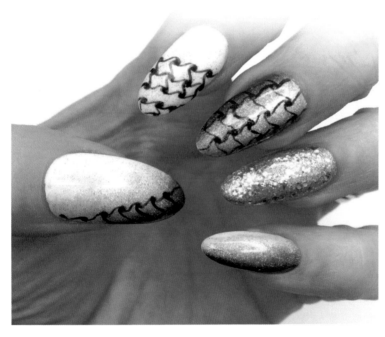

I personally like this look, it is a series of different nail designs running over all ten nails, they have a common theme or colour so they all look like they belong. Make sure you heed the three colour rule, and stick within your colour palette. (remember white and black don't count)

I would also stick with three designs and repeat. Find three looks which will work together like an ombre, negative space and a simple rose for example, then you can change the colouring or position on the other fingers. Place these three initial designs on the index, middle and ring. Repeat one on the thumb, and add solid colour on pinkie (or the other way around if your prefer).

Think about the fingers and what should go on them

• RING - the nail that sells, this is the finger which will pull all the colours and the design together. The focus of the show.

• MIDDLE - as the longest finger, think about a design which is heavier nearest the cuticle to balance the look.

• INDEX - don't mimic! This finger should compliment the ring finger, and have an element of the design within it.

• PINKIE - small but effective, don't under estimate the power of the pinkie, this finger can hold your embellishments and more.

• THUMB - the fail safe, you can repeat a design used on any of the other nails or black out the nail with a solid colour.

Ring Finger, Accent & Bling Pinkie manicure

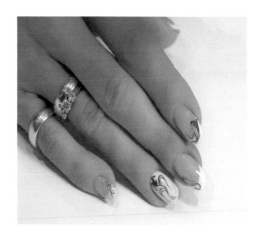

Otherwise known as an accent nail, it has three things going for it. It is a cheap way for clients to get art on their finger tips, a wonderful solution to dip a clients toes into the world of nail art. The third thing is it's quite subtle and the reason aimed at which finger you choose. The ring finger is said to be a perfect canvas because of the whole hand it is used the least.

It doesn't move independently and it is considered the gentlest finger. Also for attractiveness, applying art on the ring finger is more effective because it is the finger which draws the eye, generally from men to see if there is a ring on it.

Using other fingers tend to come with coded messages if you're in the know. Do I need to explain what the middle finger represents if held a certain way? That F@*k you attitude on the longest finger and generally the widest, it goes a long way to say you don't care what people think.

The pinkie is generally called the party nail, loading it with gems and glitter means you have created the bling pinkie. It can also be the longest nail as it is the least used like the ring finger. Back in the 80s people used to keeps their pinkie's long so they could scoop coke and snort it, can you see where the term "party nail" came from?

Nail art is not just for girls either, and rocking an accent nail on the thumb is a great way for guys curious about rocking nail polish. Thumbsies are basically a fun design done on your thumb. For nail artists, wearing art on your thumb is great advertising. It is a way to get your designs on show, as you work on your clients hands. But for the general public, the thumb is off to one side, easily hidden and a way of adding little self expression without ruining your whole look.

Luna manicure

Sometimes called the vintage manicure, it is when the half moon or Luna are left bare and the rest of the nails are painted.

You can either add nail art within the Luna area or on the polished area. Most of the time adding the nail art around the cuticles is also classed as the Luna manicure.

A common way to achieve this look is to apply two contrasting colours.

Fancy French

Very much like the Luna manicure, the nail art or glitter is added to the free edge. This is a subtle way to add little sparkle or delicate lace design to a nail, especially for weddings.

This can also be a heavy colour on the free edge and another way to add a splash of colour to someone reluctant to cover all their nails. The French and Luna manicures are both fantastic for someone with short fingers, leaving the Luna and nail bed nude and adding colour on the tips will give the illusion of longer fingers.

Textured manicure

Not a common manicure, but one worth mentioning as it was a 'trend' throughout 2014. Made popular with the Caviar (bullion beads) & velvet (velveteen) manicure, you could also get this look by piling on the Swarovski crystal or having glitter exposed and not covered with top coat .

Adding bullion beads and velveteen to the surface of the nail to give a texture, either a rough or soft surface could not be maintained.

Velvet Hearts

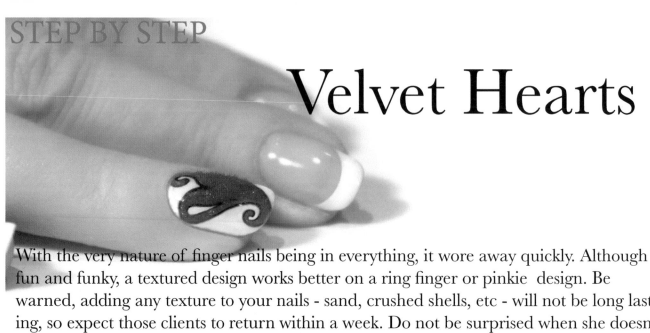

With the very nature of finger nails being in everything, it wore away quickly. Although fun and funky, a textured design works better on a ring finger or pinkie design. Be warned, adding any texture to your nails - sand, crushed shells, etc - will not be long lasting, so expect those clients to return within a week. Do not be surprised when she doesn't choose this look again. But creating some texture on an accent nail is probably the best option and couldn't be easier with these simple steps.

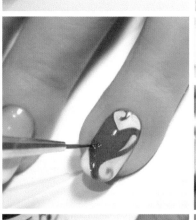

Apply a gel polish base colour over the nail. Cure and top coat with matte top. Draw out your shape, in this case we are doing a graffiti heart.

Use gel polish or paint to add colour to your shape. Use the same colour as the Velveteen you're about to apply.

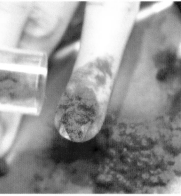

Add detail and outline in black, if this is part of your design.

Top coat just the area you want the velveteen to stick to, you should use a regular polish topcoat which is not a fast drying one.

Sprinkle the velveteen over the wet top coat, leave it for 30 seconds and gently tap the nail and brush off access.

The Full Look

We must not forget the whole look, the reason why I love nail art. Applying nail art over all ten nails is a delight. But there are a couple of rules I would advise you follow;

Don't do the same thing in the same place on every nail, this will just look like you have applied stickers.

Definitely think of all ten nails as one canvas, and have your design grow across all of them.

Imagine each nail is a page in a book, continuing the story across all ten chapters.

Not every nail needs to be filled to the brim and detailed, having a design as simple as an ombre or colour fade over all ten nails is as stunning as having pictures and design work.

Now that you have figured out the types of manicures to offer, we need to chat little about the type of designs. There is more than I could ever list here in this book, but I thought a short list of the most common to get you started.

Understanding the types of nail art manicures and separating them from the different nail art designs and applications means we can now make sense of what we can offer our clients. These two elements can be mixed and matched to create a look which suits your client. I will cover the list of nail designs in more detail in the nail art chapter.

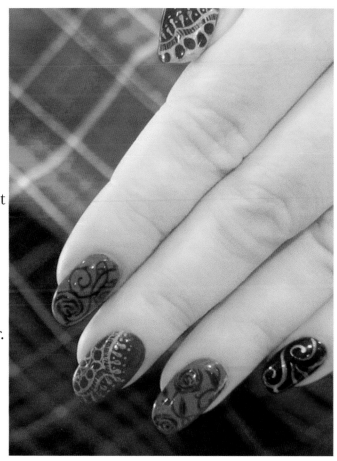

Before we go into building a portfolio and selling the right nail art to the right client, I thought I would show you a three step method for collecting and storing inspiration and then help you build on your design themes and manicure looks.

1. What are your Nail Art examples?

Coming up with designs in the first place is hard. I won't deny, sometimes I am scratching my head in desperation hoping something will magically appear.

Google is your friend; collecting inspirational images, nail art images and ideas is something you should do every week. Start building your inspiration folder today.

Have a file on your desk top or a board in Pinterest. You could have an album on your phone. Segment your files into themes like negative space or ombre and collect images. Add at least 10 different examples to start with of a particular style or theme. Don't just look for other people nails, find images with the effects like lap top covers or outfits.

These will help you with colour combinations and texture.

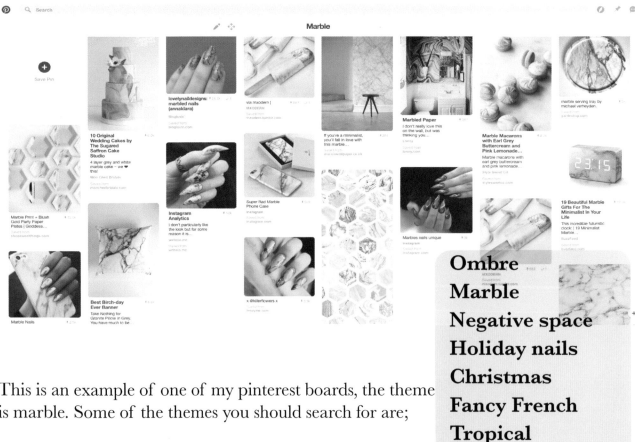

This is an example of one of my pinterest boards, the theme is marble. Some of the themes you should search for are;

Ombre
Marble
Negative space
Holiday nails
Christmas
Fancy French
Tropical

2. Colour Matters

I always start with a colour - generally this is the only input my client has - and then add the other contrasting or complimenting colours around this first choice. Don't think about design or look at this point, because it is the colour which should be your guide.

3. Put the design together

Now decide on your manicure; is it ring finger, combined look or fancy french? Once you know on how many fingers your look will sit you can decide on the nail art application. Will it be pictorial, floral or ombre? Look at your inspiration reference system and find a design which will fit in nicely.

EXERCISE

Build up at least 3 folders, either online or offline and title each one with a theme suggested in the blue box on the previous page. Then follow the steps again as listed below and decide on a nail look. I have started you off with an easy one.

1 We have done our research and know the looks available; ombre, negative space, floral.

2 The client wants a nude on her nails with subtle nail art.

3 The overall look is going to be a ring finger manicure with accents on the other nails around the cuticle and free edge.

So lets decide on the design; looking at your folder you need to come up with a design which is very light and pretty, sits well alone on the ring finger and can still be stretched over the other fingers as well. You could do a soft ombre design from skin to a beige tip, but your client wants pretty.

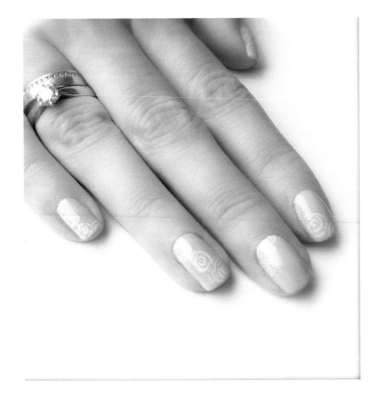

Pretty is code for lace or floral in my experience. This is a soft, simple and subtle enough design for those shy clients not ready to tread into the extroverted world of nail design.

I shall show you how to create these roses in more detail later on in the book.
This simple application is using paint over gel polish or regular polish. using acrylic paint to create the roses. Then top coat your design when dry.

If you went with a combined look, you would choose one look from three different files in your inspirational reference folders and change the colours to suit the clients colour choice.

Now it is your turn.
Start building a portfolio of 10 different looks. Either on Pinterest or on your desk top. This will become a reference for you and will help you understand the different nail art looks and trends.

Don't just look at nail art, look at other images that include these design references too. Refer back to my Pinterest board of a marble design. It will all help when you're pulling on these resources at a later date. You don't need to make these public, this is for your own reference.

Building a portfolio that sells.

OK so if we are honest, we both know that your client will get what YOU WANT to give her when she asks for nail art, but you need to find the client who wants the nail art in the first place. There is a couple of simple things you can do to find them, plus it is a great way to learn new skills too.

The first thing we need to do is build a collection of nail designs which are attractive to your clients. You want to be able to sell them these designs right? We are touching briefly into the realms of marketing here, and I promise to keep it brief. But when we create a nail design that is effective, we need to keep in mind the WHO, WHAT, WHEN, RULE.

WHO will wear the design? Consider the age, profession, tastes, and culture. Do they want something light or loud on their nails?

WHAT type of look does your client like? Is it a combined look which is different on each finger, or a one finger wonder? Do they like a french look or full colour? Can they cope with colour or are they a monochrome maniac? Is it sparkle and glitter every time or Matte and flat?

WHEN will they want their design nails? All the time or just for a special occasion and holidays? Do the designs need to be toned down for work but loud and proud at the weekend?

Now the second thing we need to do is create a selection of design examples which will suit all your different client's desires, from accent nails, light or loud designs, seasonal ones, and combined designs. Suit designs for different age groups and develop a portfolio which is specific to a particular 'type' or profile.

You have a work sheet to help you plan and organise your client preferences, so it is easier to plan and place specific looks. Why do you need to do this? It is fundamental to getting all your gorgeous artwork onto your client's nails. It is all fine and well being a great nail artist, but being a poor one will suck. Having this formula will help you broaden that creative mind of yours and build on a formula which sells

WORKSHEET

WHO - WHAT - WHEN

I have started you off with these columns where you can list your Who, What & Where. You need to pin point one type of client per sheet. Print off a new sheet for other types of clients and their potential preferences. Please add more options when they come to you. DO NOT get stuck in the taste of your clients, if they like floral, monochrome, subtle, or bold this will come when you create different options for each different nail 'look'.

WHO	WHAT	WHERE

EXAMPLE;

WHO; Mother - she is mid 30s with little time to herself. She would like to feel beautiful but the reality of it is that she doesn't. Being able to see some nail art will give her a hit of feeling individual.

WHAT; Ring finger manicure - it is quick to apply and subtle enough for it to not look odd when she is running around after the kids.

WHEN; Everyday because she is free - when the kids are at school - to be a regular client and get something new each time.

NOTES ON DESIGN IDEAS.

sketch some ideas on these nail templates.

Planning your designs

When doing a more complicated design, or traditional nail art, planning it is essential. It may seem like a nail technician is creating a design out of nowhere, but there is a plan somewhere, in their head or on paper sketched out before. It is necessary when recreating something realistic and recognisable, and you want to add some new dimension to your art work.

This is a break down on how I planned this tropical palm look and sketching it out on paper is the third step. After finding the inspiration, as I explained earlier in this chapter, drawing it out over three small rectangles allowed me to visualise the finished design and see where things should be placed. It also gave me the basics; shape, form, and colour choice. Sketching is a great way of releasing the chatter which goes on in my brain about what I should draw or paint next. Getting the information and making notes about the 'look' out on paper means I won't rush through the design to get to the next stage.

Here are your 3 steps to planning a nail design:
1. Decide on your theme, this design is a tropical look on a sunset.
2. Collect inspiration or look at your inspiration reference folder.
3. Sketch out the plan, draw it over three or five nails.

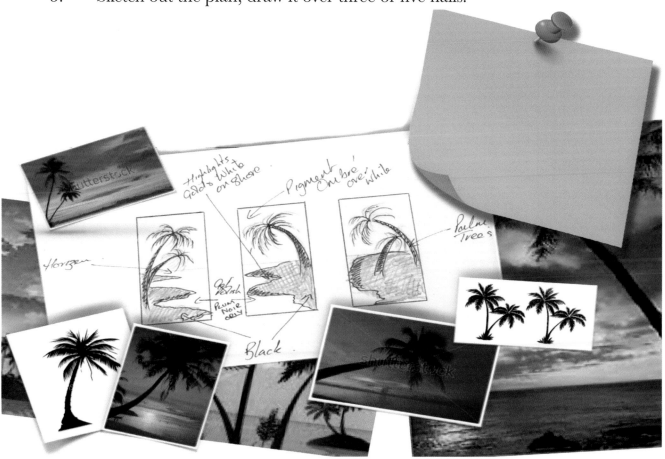

WORK SHEET

Use this page to practise the steps above to building your design.
Find a theme for your nail art, build an inspiration reference portfolio
based on the theme. Then sketch out your design.
I would photo copy that sheet and use it every time you have
 an idea.

THEME NAME

NOTES

THEME NAME

NOTES

THEME NAME

NOTES

EXERCISE

I thought I would leave you with an example and a challenge to get you started. Sometimes we don't always like the inspiration we are given - perhaps a client has arrived with a particular dress or scarf she wants to match - but we must build on what we have. Using the work sheet below and the inspiration I have added for you, design some nails. I have started you off...

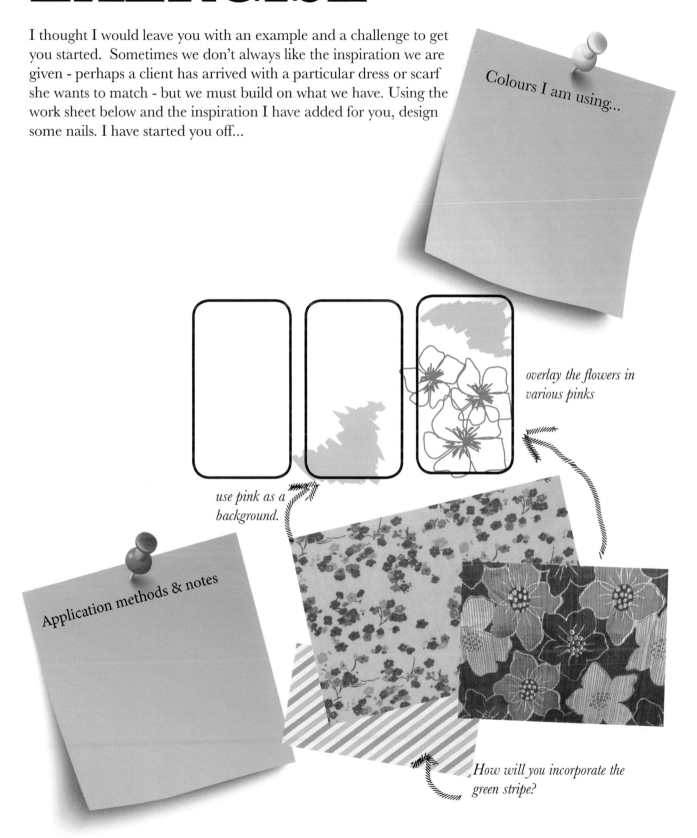

Colours I am using...

overlay the flowers in various pinks

use pink as a background.

Application methods & notes

How will you incorporate the green stripe?

NAIL ART WORKSHEET

Theme Name_____

colours

your inspiration images

KEEP IT SIMPLE

For the last few pages in this chapter I have been talking about design; how to plan it, how to build a mood board and portfolio, and how to create a design to suit a client. It all seems very complicated right?

You know when I first started teaching, I did it instinctively. I knew how to structure a class from my own experience and relate to the students. But then I went back to school and studied the art of education, how to actually teach and be qualified to do it professionally, I hated it, it sucked the soul out of something I once loved doing.
One day I went to my lecturer and said, you have sucked all the fun out of teaching, there are so many rules and guidelines, should and shouldn'ts. I don't want to do it any more. She smiled at me and told me this; "before you did it from the heart, you now have the knowledge in your head. When you have learnt this, your heart will take over again, but this time it will be more informed, you will have a clearer picture of what you want to achieve and your students will have a better outcome."

Learning all the theory is not so much fun, trying to remember how to do things in the right order is also tedious when you have done it your way for so long. But there is some-thing to learn from this. The more you have a structure and build on these new habits, the easier nail art and nail design will become.

Emptying your head of ideas onto a mood board or a worksheet planner is not a bad thing, because if it is empty then more ideas can replace it.

Knowing who you are designing for will give you a clearer idea of what you should be focusing your skills on. All these things will fall into place, and become second nature. You will find your own way of doing it in time, but stick with the things we have discussed in the chapter for a little while longer, I promise you it will pay off.

Before we move onto the Nail art I want to remind you again my three top tips to master-ing nail designs.

1. Finding inspiration: We see these wonderful creations on Facebook, Instagram, and Pinterest and think; yeah I can do those. Or we might look at them and weep at the complicated design and think I could never achieve that. We are artists, designers and creators of all things beautiful and of course we are professional self doubters. The question is not I can't do this, it should be, 'how can I create a nail design for my client which is one step ahead of my competition. How can I make money providing nail art?' Inspiration is everywhere, not just on other people's nail designs. All around us we see colours, shapes and designs. Instagram, Pinterest and google are my three hot spots for ideas. I don't type in nail art though. If I am looking for something, I look at cake making, flower arrangements, cards and wallpapers. I also check out art work and sketches. Simply type in a subject, for example, easter cup cakes And your inspiration will there right there on the screen. Don't forget to store this in your inspirational folders.

2. Translate your inspiration into a nail design: Ahhhhh now here lies the problem, all these wonderful ideas in front of us, but do you have the skills to translate that onto a nail and come up with a design that works? DO NOT ever look at your inspiration and think, 'I have to get that all on one nail'. Separate the shapes, list the colours and find the theme behind the image you're looking at. Use the planner I have given you and sketch out the elements on the nails. Repeat the colours and shapes and make sure there is a flow from one nail to another. Just take one element from your inspiration and add it to one nail, add a second element to the second nail and so on.

3. Know when to stop: The one thing I see nail techs do over and over again is over compensate because of their lack of confidence and just keep adding more! There are lot of nail techs looking to social media for inspiration, other people's work and try to recreate the looks they like. This is where their problems start! STOP right there - copying other peoples looks and designs will not only stunt your creativity and hinder you, it will make you doubt your abilities and leave you frustrated! Trying to pull together three looks into one is going to overcrowd your designs and make them look messy. You need to K.I.S.S your nails. Keep It Simple Sexy. Too many times we over complicate the process or design because we think it is not enough or too easy. Step back, look at the clock...tic tic tic. Every second is costing you money. Simple dots, and a swipe of the nail art pen and boom your client will stare at you in wonder, posting her Nailagram pics instantly with pride. The complicated stuff can happen in your own time, when you're relaxed and confident and you have earnt your pennies.

One last thing I want to leave you with my inspired nail friends:

Never Apologise for the Price

You have created some nail art on a client which might actually take you about 10 extra minutes on your service. Now you're thinking half way through the treatment, 'should I charge my client for these extra 10 mins, this was very simple and easy, it seems like I am conning her."

Think about the costs of this nail art;

The training to learn the application	£
The time to come up with the design	£
The tools and materials your using	£
Your overheads and costs	£
Those 10 minutes to apply	£
TOTAL	£

Yes, you could pop a few gems on and create a fade with pigments in your sleep, but she is happy enough to pay for that little bit extra. Wouldn't you? Don't devalue yourself, you have to re-invest in your learning to stay ahead of the nail game, and this is how you pay for it.

Nail Art

In this chapter we get to the fun stuff. From drawing out design elements to step by steps of the common basics. But before I go into it, I want to cover a couple of hurdles I think most nail techs, including me, face.

The power behind Practice

So you have your design set up, you have collected the inspiration and filled out the planner and now you want to get into the nails. So you start, and it is just not flowing. The design is not coming out as planned. It is the most frustrating feeling in the world.

What do you do? Throw your brush down in a tantrum and leave it, never to return to this idea at all? Or do you pick yourself up and persevere until you have something that looks vaguely like the plan in your head for you to then throw it in the 'nail art disaster draw', so it can live in the back in disgrace.

When you come to creating your nail design and find your fingers are just not doing what your brain can see, then you need to take a step back. Grab yourself a nail tip and apply just one element of your design, practice it over and over again. This tip you can throw away, I give you permission, but having a fall back tip will go a long way to getting you warmed up.

Imagine you wanted a glass of water and put the glass under the tap but didn't turn the tap on. Your glass is not filling up at all, right? But you have started the journey towards ending your thirst by placing the glass under the tap. Imagine you have a nail idea but never sit down and do it, your idea will never be realised.

So now you switch the tap on but there is an air lock and the water goes everywhere, still not filling up your glass. Starting a new nail design is like an air lock, you have all the pressure, or in your case, the ideas in your head but your hands don't understand it. In order to fill the glass with water you need a steady flow from the tap. The same applies with creativity. You want to have a steady flow of creativity flowing from your head to your fingers. Get the air lock out of the way with little practice on an old nail tip and eventually your brain will calm down and you will have the muscle control to do what you know you can.

Muscle memory

Talking about muscle control there is another very important reason why you should practise separate elements in your designs, for example swirls, lines or blends. With every line you paint with a brush you're developing muscle memory. Your hand muscles are remembering how to hold the brush to achieve a line thin enough for your design because you have done it ten times already on your practise tip. When you come to do it for real, your brain is not having to nag your hand to hold the brush at a 90 degree angle, your brain can concentrate on the direction of the line. When you try something for the very fist time you can see how much chatter is going on, you're second guessing everything and not really sure about the outcome. Remember the first time you had to ride a bike or when you took your first driving lesson. There is so many different elements and muscles to control, your creativity and inspiration is set to one side as you concentrate. It is the same for everything we do for the first time, so you should split down the elements and practise them individually. Build muscle memory and more importantly confidence and understanding in what you're trying to achieve. You will find, after this practise the application is smoother, your confidence in the design is stronger and all of a sudden new ideas will start to form because you're not concentrating on the application itself. Your muscles

have it all under control.

Finish what you start

Do you give up at the first hurdle and find that you never complete a design if it goes wrong?

I know the temptation is great to put a nail to one side when it is not going to plan or just won't turn out right. But trust me when I tell you this: ADD TOP COAT. The top coat will do something wonderful. All your brush strokes will be evened out, all the layers and harsh lines softened and flattened a little. Your nail might not be what you set out to do, but it will be a decent looking nail. You never know, it might even inspire you into a different direction.

What is Nail art

I won't lie to you, I got to this chapter and thought where do I start. There is so much I want to cover. How do I create something in a format that you will be able to follow and more importantly learn from? I went back to my online education course and followed the journey I take my members on. Each lesson they learn a new skill to take them onto the next one. I think this is the trick with nail art. We all know what it is; art on to nails in either gel, acrylic, paint, or multi media (gems, stickers and glitter). I have also chatted to you about the history of nail art and gave you a list of the most common nail art designs in the design chapter. Now I shall show you with pictures how to achieve them.

There are so many different methods and designs that I just don't have the room in this book to show you. It is a shame I know. The chances are you know most of them anyway, so I wanted to bring you some alternative methods; teach you a new way of coming at your nail art design which incorporates what we have spoken about already in previous chapters. Using the steps included in this chapter, I think you will be able to use this as a guide to build on.

Find out more about the online training at www.sambiddle.online.

Ombre, Blends and Fades

These are all the same and can be done with gel polish, polish, sponging, acrylic, and of course pigments; which I am going to show you here. The actual application of Ombre can be varied depending on your preference and the material you use. The most common and effective of using gel polish is the sponge method.

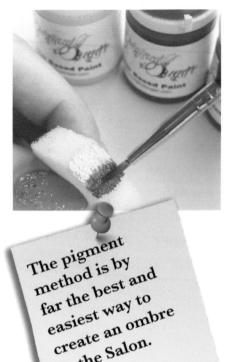

After you have applied the base coat and a light base colour or white, apply the three colours you want to Ombre from light to dark onto a sponge.

You can do this in Polish or Gel polish. Dab off the extra onto a paper towel and gentle dab up and down the colour Ombre to mix them in. Then repeat this action and dab it over the surface of your nail. You will find it Ombre's beautifully. Cure and top coat.

The pigment method is by far the best and easiest way to create an ombre in the Salon.

Step 1. Apply your base coat and use colour, depending on the opaqueness of the pigment will depend on the colour you use on the back ground. I would suggest white to make your colour pop out. But for a soft Ombre like the baby boomer I showed you in the chapter 2, applying a soft pink will also work.
Step 2. Add your first colour, then remove the excess off your brush and dab the brush a little more so it fades out slightly.
Step 3. Your second colour should be applied slightly lower than your first so you see the white gel polish through. Then remove the excess and blend it so it goes up into that first colour. Repeat this method as you go down the nails for as many colours as you like.

The Mixing Zone

Now you have your Ombre you can leave it and enjoy the rainbow effect, or paint a design over the top of it. Another option is to scratch through the pigment, and reveal the gel polish colour underneath, much like at school when you scratched through black crayon to reveal colour.

This step by step is a fantastic example of using your Ombre and painting over the top, either with a brush or the nail art pen. I want to show you how you can use Ombre's and blends as your background to enhance the design you're applying over the top.

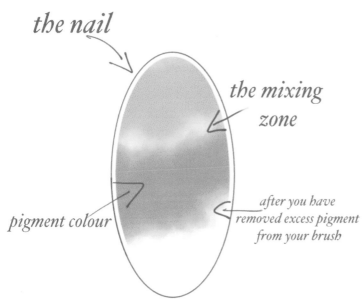

the nail

the mixing zone

pigment colour

after you have removed excess pigment from your brush

I can't stress enough how important it is to have that mixing zone between the colours, so you can come back and layer the yellow and orange to blend it. The last thing you want in an ombre is lines. The eye should travel across the fade or blend without a border or jump in colour. It should be smooth and seamless.

In this example we still have to add the third colour, but before we do, I need to blend the first two, by layering the orange over the yellow and repeating with the yellow over the orange within that mixing zone.

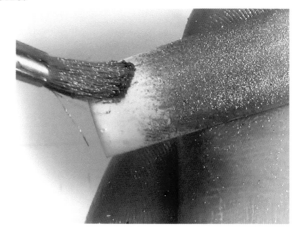

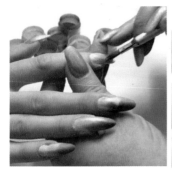 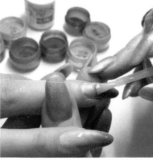 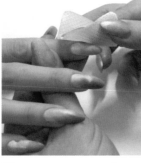 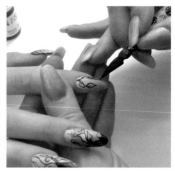

Apply 2 coats of gel polish, curing between each layer. Use white for a clean bright look. Then press the pigment into the sticky layer, creating a multi coloured rainbow effect.

Apply top coat over the pigment to fix it. I am using a matte top coat, to make it easier, I shall be applying a design with paint. If you don't have matte, use a base coat at this stage.

Cure your top or base coat under the gel lamp and then wipe off the sticky inhibition layer.

Dip your nail art pen, so the nib is fully covered with Acrylic paint. The Be Creative paints are the best to use as the viscosity is thin. Draw your design over the surface of the nail.

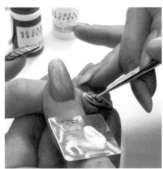 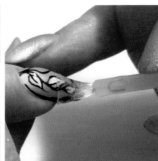

Add highlights using either the nail art pen and white paint or with a detail brush. The orange brush from be creative is best for this.

When you have applied your design top coat and cure.

Make sure you follow the instructions on how to use the nail art pen from the www.sambiddle.co.uk website.

Negative Space

This continues to be a popular design, and something I often get asked how to do. The art of negative space is to leave a portion of the colour application free from anything, so you can see the natural nail and in some cases a colour underneath. Although I wouldn't say that having a different
Colour is necessarily negative space. The process of application is a simple one but the patterns and designs can make it look complicated.
Lets start with the basics and I will show you the art of negative space.

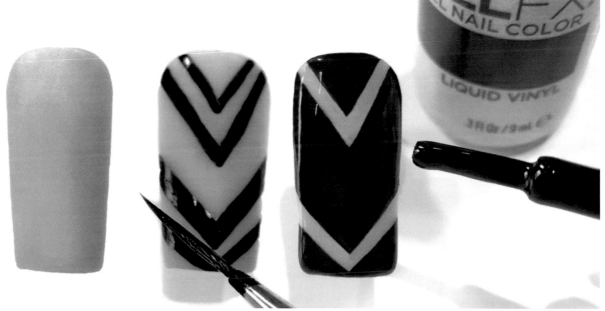

This is one step by step which looks harder than it actually is.

You simply need a striping brush and acrylic paint, to form your pattern by creating the lines. Don't over complicate the design, and make sure you have in your mind what will be left blank or negative and what will be painted, in this case in black.

Once you know what lines to leave, you use your gel polish and fill in the areas and cure.

Negative space is not complicated to create at all, but it does look more complicated when complete, which is the wonderful trick of this design. Remember, keep it simple and don't get carried away.

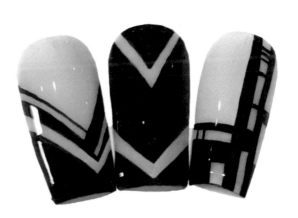

WORK SHEET

It is always best to draw out your design ideas on paper first, before you come to the nails because we can get so carried away we over complicate the look.

Below are some nail shapes, and I have started you off. Just using black and white, colour in the areas which will not be negative. Don't forget to add some notes, jotting down the names of colours you might want to use, or patterns as they come to you.

dark blue & light blue

pattern or ombre

extend the nail bed with cover pink

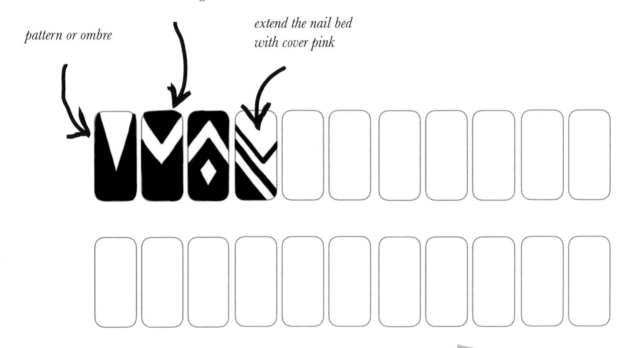

It is important to add the notes, as your lines and shapes flow your mind will be adding details and colour options. Write them down as you go and when you come back to this you will find it easy to develop some tips to display and market this look.

STUCK for ideas?

Google; Negative space nail art. Look at the shapes and make a start with some you like the look of.

Flower Power

In a lot of my classes, drawing a flower becomes quite a challenge for some students. Mainly because they don't visualise the end result, or can't see how each petal joins to make it come together. For me the best way to teach is to draw it out first. This not only creates muscle memory, but gives you an idea of where each petal should be. Before you go into this free hand, follow the steps below, but use your pencil and draw over the lines on the paper. Do this a few times and then come back and do it on a blank piece of paper. This will not only build your confidence, but your muscles will know what you're doing and help out a little.

Over the next few pages I shall give you a flower to trace and draw and then a design to use this flower in, based on the work we have already done so far.

 Start your rose with the centre. Create a yin and yang symbol. Make sure they look like comma's and not seeds. Make them fat and round one end and pointed at the other, so they curl around each other.

 This part is important; you need to draw a line so it closes the gap the original step created. This petal scoops around the yin and yang symbol and blocks the area where there is a small gap.

 Make your petals ragged and so they create a triangular shape and not long thin lines that look like sausages. End the petal tips so they nearly touch their opposite.

 Carry on filling in the petals, so they cover the gap where the two previous petals nearly touched. You will notice the petals get thinner the more petals we add.

YOUR EXERCISE;

Now trace over each drawing, starting with the first step, continue and draw the final finished rose.

On the blank paper draw the rose again, copying the picture. Continue to practise these basic roses on another blank sheet of paper. I have given you a worksheet to help you with more practise.

You can not go wrong with this rose, there is just 3 basic rules to remember;

1. Make sure you keep the lines close together
2. Use the petals to cover the gap/space created by previous petals, so you don't create a repeat pattern.
3. Make sure your petals are not skinny, make them more triangular.

WORKSHEET

Use this page to practise on. Draw over the image in each step and immediately draw it again on the blank square. I know it seems like a simple task, but doing this will stop your mind filling in the blanks and drawing something you're not looking at. Use the final blank page on this sheet to draw a complete rose, after you have traced it.

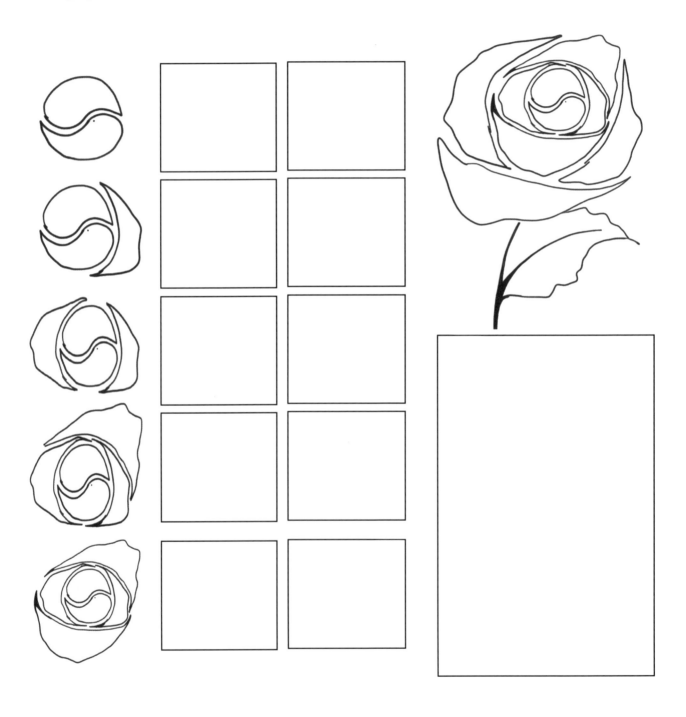

Now we have the basic rose, broken down so you can see the components. Lets put this into a nail design.

Firstly prep the natural nail and apply base coat, and two coats of colour. The choice is up to you, but make sure your have the pigment to compliment it and the paint colour to match so you can tidy up. Cure each layer and then wipe off the inhibition layer with some cleanser. There should be no sticky layer at all, otherwise the pigment will stick to it. (DO NOT TOP COAT) if your worried about wiping the layer of inhibition off, then apply Matt topcoat and wipe. You can reapply gel polish top coat on a matt service without the risk of peeling and chipping.

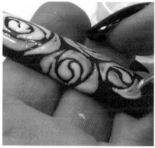

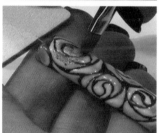

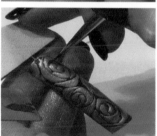

In this next stage you need to use a gel paint. This is a gel product designed for painting. It doesn't have the self levelling properties that normal gels have and you don't need to cure between each application. I am using Gel Paint from Be Creative available at www.sambiddle.co.uk. However there are other brands out there. Following on from the tracing you have done, start to paint those roses. Continue to fill the whole nail, and overlap the petals, so there is little blue showing. You want to achieve a 'wrapping paper effect' like a repeat pattern and not 3 or 4 roses in the middle of a nail.

It is important to use gel, and not acrylic paint at this stage, because after you have cured it, you will be left with the inhibition layer, that sticky service. We are going to create an Ombre with pigments, like we have done before, but this time from the centre out.

Use 2 or 3 pigments which compliment the back ground colour you applied. I am using 3 different blues from the Pigment range by Be Creative. Ocean from brights, Forget me not from the pretty collection and for that shimmer Blue dragon from chameleon collection. Start in the middle with the darkest colour on each of the roses, apply the lighter blue and then add shimmer. Now with a soft blusher brush, brush away the excess, and all the pigment that should remain will have stuck to the gel paint.

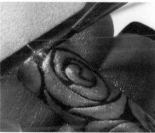

It is important to use a paint that absolutely matches the back ground colour, if you don't have it then you will need to mix the colour. This stage is literally to tidy and crisp up your lines.

Another option, is to use a thin brush with some cleanser or monomer and clean around the rose petals, just to remove the extra pigment.

By adding the paint lines you can correct some mistakes.

The final step is to add top coat over the whole nail, and make sure you cap the free edge as well, to prevent chipping.

This nail has been included to show you flowers is not just plonked on a nail, you can use the shapes to create patterns and covers.

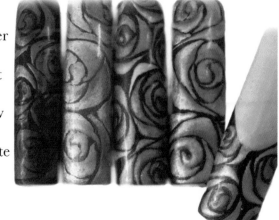

Lets do a similar design using a different flower. First I want to discuss perspective. If you look at the rose you have just done, you will see that it is very flat and there is no direction. It is looking at you, face on. How do we draw a flower which might be facing away from us so we can only see the side view? This is called perspective and not that hard to achieve.

So imagine your flower is facing the sun and not you, we can only see half of the flower, the petals at the back are only partially viable to us, where we are standing. If we move or tilt the flower then we would be able to see more of it, and the petals at the back with come into view.

With this in mind, start with the centre of your flower. This should be an oval, because remember we are not looking at it face on. If we were then it would be a circle.

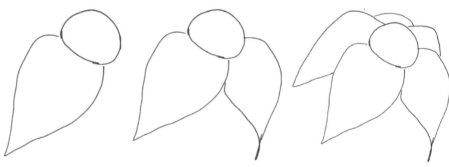

Now for the clever bit. Those hidden petals! You need to create a small hill, behind the centre of the flower, this will be the visible part of the petal that bends away and out of sight.

Add the second hidden petal, to achieve your 5 petal flower. Shading is a key element in any art work, this brings your drawing to life. You can see where I have placed my shadow in order to give height to the centre of my daisy.

The stem and fine lines here will give you a better idea of how it should all come together. Look at the shadow to the back of the centre of the flower on those hidden petals. Can you see that the centre is casting a slight shadow there, as it is nearer our view point.

My suggestion is to trace these sketches of mine and then draw this out yourself.

We are now going to combine these new skills into another flower design, this time we shall be applying the ombre in pigment behind and drawing our flower over it. The flower will have perspective and use the colours in the Ombre to enhance it. But first we have some more sketching, building that muscle memory so using your paint and brush will be a dream.

Start by tracing over each individual petal and then copying it in the square provided. repeating each petal shape with strengthen your muscle memory making it easier to draw.

Always start with the petal which is nearest to you. Draw in the additional lines to give the petal a 3D effect and creases.

Now draw a line for the second petal, coming from the center of your flower

You will need to fold over the edges of your petal, don't forget to give it a ragged edge.

Add creases and directional lines to simulate the position of the petal growth.

Now for the back petal, done in a similar way

Start at the other side of the first petal and make this petal smaller, don't forget to add the crease lines.

Finally add the last petal with the ragged edge to fill the gap.

Colour in the centre and create a stamen from the black center.

STEP 1 Prep the natural nail and apply base coat, and then I recommend white, however you could use a yellow in this case, the choice is up to you. Cure each layer, DO NOT WIPE, this time you need the inhibition layer for the pigment to stick to.

You will see on the previous page the steps of applying the pigment ombre, this time instead of top to bottom we are spiralling out, so the flower has a nice dark centre and ombre's out to yellow. Follow these steps and then base coat or matt top coat and cure. Now your ready to add your flower design. Top tip - practise this on paper first before you use the nail art pen or your brush to apply the paint.

 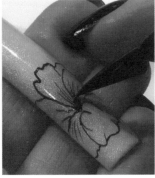 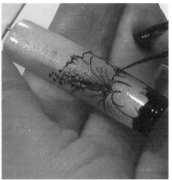

STEP 2 - Use the nail art pen or a brush and start drawing the first petal, as I showed you on the sketch steps. Continue by adding five petals to your flower. Make sure you add the creases to the petal giving the flower a soft look, but don't over do these lines, we don't want wrinkles.

STEP 3 - Colour in the centre of the flower, keeping the overall look simple by just using black paint and letting that ombre behind the nail shout out.

STEP 4 - Create a tube from the centre of the flower with a slight curve that's wider at the base. Using the nail art pen, add small dots which will be the pollen.

STEP 5 - The final part of this step by step is to make the flower 'pop'. The yellow at the base of the nail under the flower is pulling the eye out and creating a hard line across the nail in black, so if you colour in the tip of the nail and any-where up the side until the petals stop, you will see how all of a sudden you remove the 'black lines' and the flower pops forward.

When you're happy the paint is dry, top coat and cure your nail art. One final embellishment you could add is smaller dots of gold around the black dots, to lift the centre and of course add a slight shimmer.

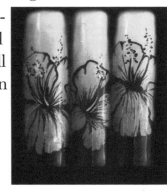

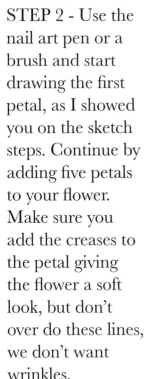

Leave out the Leaves

So we have done some flowers, perhaps practising some leaves to go with them might be a wise thing, I have given you three simple leaf shapes for you to try here, it is worth your while doing them on paper first to make sure we have the correct shape of a leaf. By doing this we become more confident with the application and therefore more competent. But of course I don't need to remind you of that, I think I have said it enough already. Start with the simple shape and move onto the second one.

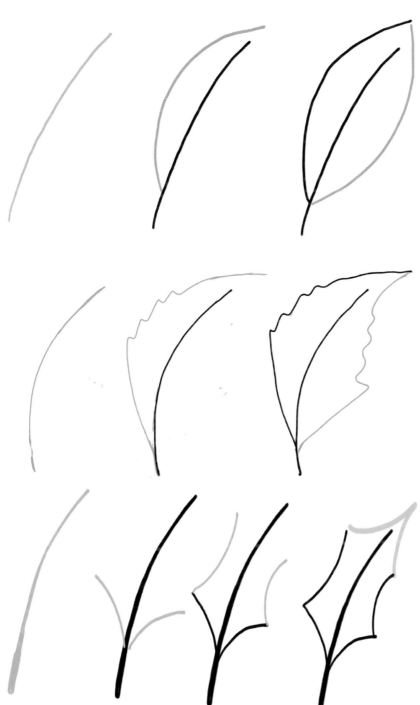

Draw a line down the centre of your leaf, this will determine the direction and where your leaf is pointing.
 Draw or paint the actual leaf, you can see how the base of the half moon starts and ends touching the middle line.
 Make sure you leave a portion of the stalk free at the bottom. Follow the green lines as your steps, and play around with the direction, by changing that first center stalk.

 Like the first step, draw the centre stalk, this one is a little more curved. As you draw the edge of the leaf, instead of a half moon, bring the line up half way along the centre line and out about 45 degrees, as you start bringing it towards the tip of the centre line give it a soft zig zag. Repeat this to complete the leaf shape. If you find this tricky then trace over the leave shapes and then draw freehand.

 You can get the basic principle with the holly, vein first, this gives you the direction of your holly leaf
 The next step is a series of half moon loops away from the centre stalk, starting first with the base of the leaf, then the middle and then the tip.
 Don't be tempted to just continue the loops around the leaf. lift your pen or brush off the service and come back to create the second set of loops.

Sexy Swirls

During this chapter, I shall be touching only on those most popular designs and asked after looks, this really is a "how to achieve the look" not a "step by step book". Breaking down each of the different applications should give you the information and knowledge to use these skills and apply them in your own work.

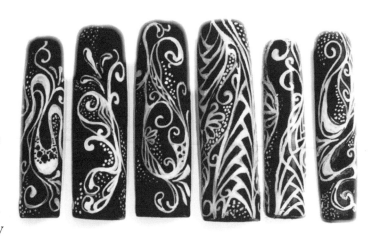

One of the design looks that I get asked to teach is swirls. Yes, those simple curvy lines which actually, when you sit down and do them, aren't so simple anymore.

I have broken the swirl spell, and now opening the doors up for you to master them with my 'simple' formula.

There is 3 simple rules to getting the perfect swirl design.

Start with the main swirl; with every swirl design there is always that focal swirl.

Work your lines off this main swirl. Make sure you follow the contour and direction of this central swirl, and have the smaller accent lines follow along side them, fanning off in an opposite direction.

Remember the line of sight…make sure your eyes follow the tracks or lines so they take you up and around the nail without jumping and stuttering. That means no gaps or spaces; each swirl section should be complete.

TOP TIP

GOOGLE "swirls" and then click the images and you will find loads of inspiration you can down load and print out. Trace over these swirls to practice and feel comfortable planning and drawing swirls, eventually you won't need the inspiration sheets.

WORKSHEET

Here is how you can practise your swirls and create that muscle memory we spoke about before. Use the work sheet and, within each rectangle, you need to draw a swirl design. Every swirl needs to be different which is easily done as you just place that central swirl in a different place on the nail. Having 10 or 12 different examples will not only allow you to refer back to them when you're stuck, but it will get your mind used to drawing the swirls and getting them to look good.

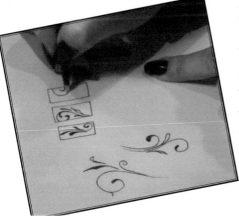

Trace over these examples to develop muscle memory and then draw them free hand in the row below

Now come up with your own swirl shapes using the 3 rules.

TOP TIP
You can have some of the main swirl on the side of the nail, not all the swirls need to be in the middle. Use the same lines above and tilt then, cut some in half.

3 rules to swirls

1. Start with main swirl
2. Work smaller swirls off the main swirl
3. Make sure the eye flows the flow of the swirls in one direction

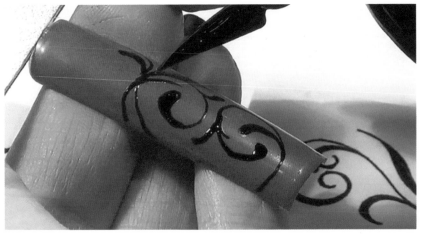

There are a few different ways you can apply swirls; with paint or gel using a pen, like the Be Creative nail art pen, or a brush. In the online education program I show how to achieve textured velvet swirls with gel and acrylic. I thought this would be a cute look to show you, incorporating the roses we have just learnt and the swirls in one design.

Prep your natural nail as normal, apply base coat and gel polish. You can do this design over regular polish or acrylic too.
If your using gel polish cure the final colour coat and then wipe off the inhibition layer. without the sticky layer you will get crisper lines and better flow of the paint from your pen or brush.

I am using a pen for this design, but you can use a brush as well. Copy one of your swirls from the worksheet, but make sure there is a large area free within one of them for a rose or two. don't forget you can combine and layer the swirls, repeat patterns, twist, tilt and turn them, if you look at each swirl they start with the same basic main shape.

Within the large area you left free for the rose, use the principles you learnt earlier in this chapter and draw a basic rose shape. To add extra detail incorporate leaves and even thorns. (I cover leaf shapes later)
When you're happy with your design, just top coat it and it's finished.
Remember Keep it simple, delicate and clean.

Find out more about the Nail art pen at http://www.sambiddle.co.uk/nail-art-pen.html

Butterfly Effect

So we have worked with pigments to create an Ombre, now let's work with the pigments to create shapes. You can do this for flowers, fish, clocks, buildings, in fact almost everything. But I am going to show you how to with a butterfly. The reason why is I want to incorporate it with an important lesson about 'seeing' shapes and translating it onto the nail. In art, the main rule is to draw what you see, that sounds simple right? Wrong. What happens is our imagination gets in the way and we start to see things which are not there. Don't panic this is quite normal, just not so great if you trying to draw something recognisable. This is great if we are doing something from memory, but first we need to learn the building blocks, and that is to look at an image and break it down into segments.

If you look back at some of the nail designs we have covered so far you will see that we have already been doing it, but I shall show you now with a simple butterfly.

Once we have the design and shape on paper, we can look at how to use the skills we have learnt with the pigment and make them work for us.

Butterfly you say? that looks easy doesn't it. But so many people get this shape wrong right from the beginning, I want to show you how I got it straight in my head, and now can draw these with my eye's closed. Well... perhaps not literally with my eyes closed. But I definitely don't need the guide lines. These steps will give you a visual on how I break an image into sections and figure out the placement of things. I am not concerned at this point that you make a master piece, just that you see the shapes, angles and position of the item when you are drawing it out.

Draw the body first, but see how it is not 1 long oval, it is broken down into 3 sections. head, body & tail.

Draw two lines from the neck at a 45°angle, pointing up-wards. Like two arms.

Now draw two legs, at 45° pointing down. You are creating an area to place your butterfly wings in.

Now add two lines so they form a V, and touch just below the tail.

Within these guide line draw your wings. It is important to know these are just guide lines.

Having the area there will help you place the wing shape, you could go over it slightly, but it is important to stick within the lines, so that you understand the position. Different butterflies have different shape wings, but lets concentration this principle, and when you have mastered it, then you can experiment and change the shapes. Make sure you follow the steps and draw your butter fly here.

So now we have mastered the butterfly front on, we all want to know how to draw it from the side. You must do the first step though, other wise this one will make no sense.

Remember the 3 parts to the body, draw this again but this time at a 45° angle, not straight down from top to bottom.

Just like before add those 4 lines at the 45° angle from the body. if your confused turn the paper round so the body is straight like before from top to bottom.

Now draw in the butterfly wing, you will notice the lower part of the wing is bigger than before and will come out of the guide lines, but this is because it is closer to you, you're creating an optical illusion.

Add the second wing BE-HIND the first, if we work with the degrees, it will be approximately 110°. if you're not sure what I am talking about, check out the Arc degree diagram.

Draw your butterfly here, and then on the next page, I shall show you how to add the details.

This is the important part, and where I see perfectly good butterflies ruined with over complicated details and veins. It is important to keep this simple, and when we come to do the actual nail design you will see that the pigment colour behind should become the star of the show, and these lines are just a gentle frame for it.

So you should have your butterfly shape drawn out in the previous page, go back and you will now add some details. Your brush strokes and lines should be thin.

Now you want to draw some loops...BUT... see how all the points of the loop are pointing towards the shoulder of the body.

Colour in around the outside of these loops, and make sure the butterfly wing behind looks the same.

Do the same for the lower wing and colour the edges. I would suggest you trace over these loops and then draw them, just like in the last few exercises. Remember Muscle memory!

Now this is very important, these veins should be very faint and thin. Water down your paint and have a very light touch. It should be barely seen.

So we have the butterfly on paper, lets go do it on a nail. What is great about this detail is the only painting you do will be the outline and detailing. The colour, ombre and blending is covered with the initial application. Think about the abstract nail and the tropical flower, we will be placing the pigment right where the butterfly wing will sit.

Here are some of the most common mistakes made with butterfly drawing.

wings are pointing in the wrong direction, this is more like a bat!

You can see the correct wing in orange, compare the difference.

the loops are not pointed towards the body and edged along the side of the wing, they are also in a row and not like a fan.

too much going on inside the loops

here, you can see how the red lops fan and all meet towards the body of the butterfly.

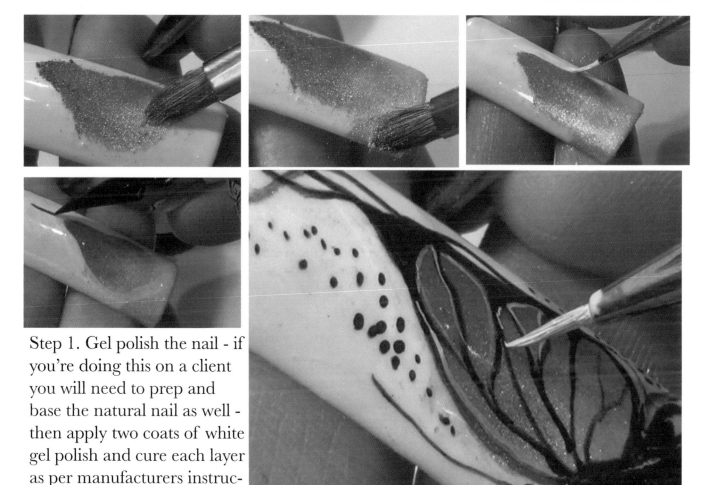

Step 1. Gel polish the nail - if you're doing this on a client you will need to prep and base the natural nail as well - then apply two coats of white gel polish and cure each layer as per manufacturers instruction.

Step 2. Apply an Ombre of pigment in the shape of a wing. Remember the rules we have learnt so far in this section. Follow them to get the shape and placement right of the wing. We are not doing a full butterfly here, just a partial of one.

Step 3. Using white acrylic paint, you can crisp up the edges of the butterfly wing, so the pigment looks nice and tidy. This is a good opportunity to correct any shape mistakes as well.

Step 4. This is important - and not shown in the pictures, but we go into detail in the lesson online. If you would like to watch the lesson visit www.sambiddle.online and sign up for the free trail. You must now apply a layer of base coat or matt top coat. We will be painting over the pigment and we want a crisp line. The water from the paint will blend into the powder and it will not look so great. With a base coat or Matte top coat it protects the layer of pigment, plus this is great if you make a mistake and want to wipe off the paint and start again. Cure this and wipe off the inhibition layer.

Step 5. Now for the detail work I am using the nail art pen because it has the quickest and easiest application. But if you're more comfortable with a brush, then there is no problem with that. Outline your coloured pigment areas and add the detail. Highlight with white. Then all you need to do is top coat and cure.

Being Marvellous at Marbling

One of the most requested nail art looks - if you have it on display that is - and I think one of the least favourite to apply by nail technicians. That information is based on nothing more than the musings of Sam Biddle. I have a theory about this and it has three parts.

1. Marbling is one of the first things you learn in nail art
2. Depending on how you were taught, it can end up looking very messy and over worked, like an over mixed bowl of Neapolitan ice cream.
3. It doesn't feel like you have added value, marble is extremely simple and fast to apply, so for the little effort you don't feel you should add the price tag.

It is a sad fact that marbling is an undervalued application and on many occasions done very very badly. That basic principle that less is more and the art of leaving it alone is the skill here.

There are actually many different ways to get a marbled effect. From acrylic and gel marbling, we can now water marble; this is adding drops of different coloured polish into water, dragging through it with a cocktail stick and then dipping your finger into the pattern. It is a lot more time consuming than the other applications and not one for the salon, although fun. We also have seen the introduction of sharpie pen and isopropyl alcohol to create a multi coloured marble effect, I think this is less marble and more psychedelic tie die. I want to show you three different methods of marbling each one very different but very effective. But first let me explain some of the don'ts when it comes to marbling.

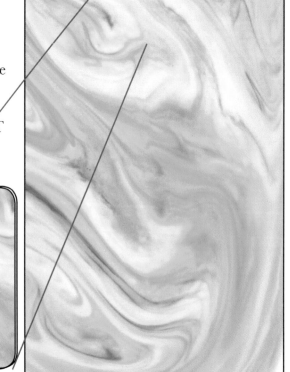

1. All too often we over colour the marble, and really it should be just a couple of colours no more.
2. Look at the lines and veins on this marble example, see how they are traveling in one direction, for the most part the veins are going from corner to corner and the additional bleed offs are joining the veins. It is important NOT to swirl the paint to create marbling, instead drag in one direction and let the paint drag the colours and do all the work.
3. Marbling on nails should look like it has been cut out from a larger block of marble. Here I have created this nail shape and how the lines of the marble continue beyond the broader of the nail. Bare this in mind with your brush stroke, continue each line or drag so it pulls the eye off the nail. Don't have it stop a the cuticle and do a loop to the next line.

I mentioned the Sharpie Pen and marble technique on the previous page, yes there has been some controversy with this application, these are not nail products and can be quite messy. You can create the same effect in less time with some pigment and monomer, it allows the pigment to be suspended whilst it dries, instead of being diluted, you can get a vibrant effect this way. I have found this is best done with the be Creative Neon festival pigments.

Cheating Marble

I love this method as it creates a cool marble effect without the fuss. Plus it doesn't take too much time or effort; those buzz words which make every nail tech smile in the salon. All you need is some cling film, and a couple of gel polish colours. Perfect in blue to create a denim look, reds and blacks for a vampy feel, or multi coloured for the festival vibe.

 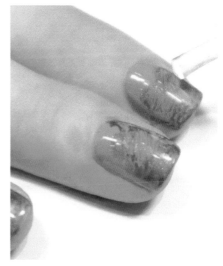

You will need to prep the natural nail and apply base coat and the colour coat of your choice. this works best if this coat is lighter than the marble coat. Dab small amounts of your darker colour over the top, you can use more than 1, or add white to this as well. DO NOT CURE this stage.

Grab your small section of cling film and pull it tight, this will stretch it slightly and pulling it will create ridges and creases in the plastic. Lay this over the wet gel polish, you can move it slightly do manipulate the pattern, and when your happy cure this under your lamp

Gently peel away the cling film and cure again, then apply top coat. the service should not be too raised or rough, if you find it is your creases where too obvious. it is important to lay the cling film flat and use it to manipulate the gel and move it instead of using a dotting tool or a brush.

Traditional Marble method

So now we have the quick method out of the way, why don't we go down the traditional route and I will share how I marble and get a great effect using multiple colours.

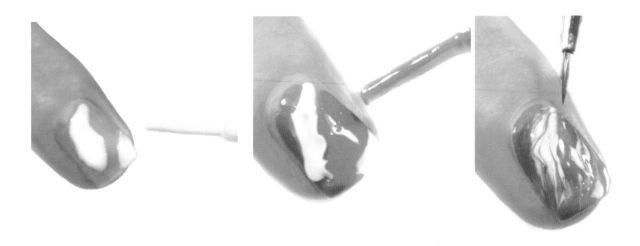

Prep the natural nail and apply base coat. You can either work directly on the base coat or apply a layer of white gel polish first. once you have cured apply a second layer of white, but can you see these are just dabs. Now don't be mean with the gel polish, you will be removing most of it, but if you don't have enough gel polish at this stage you will not be able to move and manipulate it.

The colour choice is so important with marble, I tend to stick with 1 hue and change the tone or shade of it. For example dark blue/black and a pale blue which mixed with the white will form more shades of blue. If your have too many different colours, they might not mix so well to form secondary or tertiary colours.

Using a small detail brush, pull through the gel colours in 1 direction only. Remember what I wrote earlier about criss cross lines. Make sure the line runs continuous so it looks like it could continue off the nail. Now wipe your brush and drag in the brush back down in the opposite direction. Wipe excess again and repeat. Add little wiggle and look as how the colours are mixing and the lines which are left.

TOP TIP!

It is very important, to pull one colour through another, to create those thinner fine lines. DO NOT rush this, old school habits need us to marble like a demon before the polish or paint dries, but we have plenty of time with the gel polish, so relax and enjoy the movement. However that said don't over work it, that would be a messy brown disaster. The point is you're producing a beautiful subtle movement in the colour which is effortless and time saving. No more than 10 strokes per nail, you should be able to do it in 5.

Marbling with Paint

So you can use the method I have just shared with you and do your marble with acrylic paint... but seriously why bother? There are ways of making your life easy and using gel polish does this. Using paint you're fighting the drying of means you rush. I want to show you a really cool way of using acrylic paint, any paint will do as long as it is acrylic. The material the pigment is suspended in is important, and in acrylic paints this is a polymer emulsion. When the water evaporates the paint dries, well the water allows the pigment and emulsion to move giving you the 'viscosity of the paint. More water means a thinner viscosity. So when we allow it to evaporate the polymer emulsion turns into a plastic film holding the pigment in place.

We will be creating a marble effect using water and acrylic, but you really do have to let it do it's thing and not interrupt the process. If you can do that you will achieve some amazing organic effects.

STEP 1 - Prepare the natural nail, base coat and then apply two coats of white gel polish. Cure and then wipe off the inhibition layer.

The first step of this design is to add water to the surface of the nail, work on one nail at a time, but do be mindful that you have enough water on the nail, in order for the acrylic paint to be able to move and bleed.

Pick just three colours which you know will blend well into each other, yellow and blue work because they are two primary and make green, and you could use a pink with the yellow; this would form a soft apricot.

 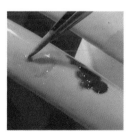 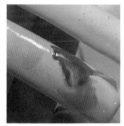

Now randomly place one small drop of pink paint on the nail, and leave it, allow the water to pull the paint and let it work it's way into the puddles formed onto he surface of the nail. Add a small dot of yellow, this will instantly be drawn to the water as well and might merge with the pink; allow this to happen. Continue with the blue. if you find there is nothing happening, it means you don't have enough water on the nail in the first place, so add little more on top. try not to touch the surface of the nail with your brush, but let one drop of water fall, and see what movement it creates.

The important thing here is to let the water do the work, allow the paint to move and flow and then dry without you touching it. You will notice what a delightful effect you end up with, and every time it will be different. When it is dry, top coat and cure.

More Marbling Moment

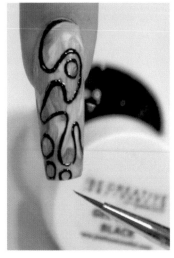
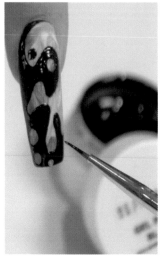

One last point I want to leave you with before we move onto the next technique. Don't think you have to apply the marble finish over the whole nail, there are many options with marbling. One of the easiest ways is to have your marble as a base and then paint over the top, a little like creating a negative space look. You will end up with a pattern which looks like each section has been marbled.

Marbling with Acrylic

It is not often we consider marbling with acrylic, but it is actually a quick and simple way of creating a cool background to art work. You will need 3 complimentary colours, triple dip your bead and whilst it is at it's gel stage, as the acrylic is polymerising, you can drag your brush gently through to mix the colours. Allow the acrylic to relax and then press into a smooth form over a sculpting form or a tip.

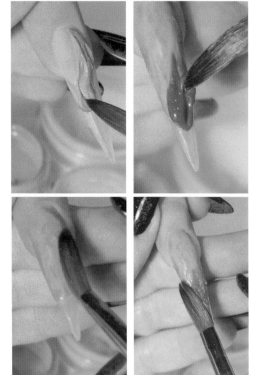

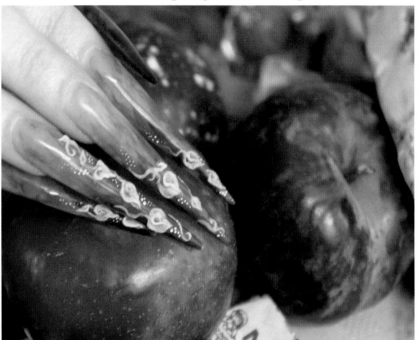

Fine Lines & Lace

Throughout this book I have shown you different designs based on application methods. It has been a combination of materials verses application. You have had options and ideas to produce the results your clients would like. But it would be remiss of me to not include fine lines with a brush; this is probably the one thing that most nail techs struggle with and I want to share with you my trick to getting that clean crisp line which is oh so thin. Another request I get in nearly every demo I do and class I take is lace: 'Show me how to get a lace effect?' Beautifully delicate threads of lace woven together, yep that is a tough ask if you don't get those fine line skills under your belt.

So lets start with the skill, and then move onto the art work:

The secret to getting a fine line is to hold the brush perpendicular or at a 90° to the surface of the nail. This means it is just the tip that makes contact, the smallest part of the brush produces the line as you drag the brush across the nail. There is another secret; be confident with your strokes, deliberate and controlled will avoid hesitation marks in your line and those wobbles. Rest your little finger on a stable surface and grip the brush closer to the bristles.

You can see in this image, that the angle of the brush is not 90° and the bristles have spread with the weight of themselves onto the surface. You can't help but get a thicker line holding the brush at this 45° angle.

But one thing you should notice with both the images is how close my hand is to the bristles. The hand is resting on the service as well to have better control when pulling the brush.

By combining both methods we can create a tapered effect like this. Press your brush at 45° angle and as you drag it lift it off the paper as you tilt it toward a 90° angle. This should be a slow and deliberate movement at first but you will find it gets more natural the more you practise.

Practising how to hold your brush is as important as practising and drawing out your design. Because it creates, you guessed it, muscle memory. This might feel awkward to start off with but trust me it will become natural to you.

WORK SHEET

Follow the exercises in the worksheet, in fact I would print it off a couple of times, and do this daily for a week. Before you come to create a fine line on a nail, do it on paper first a few times to remind your hand muscles the position it needs to be in. With your detail brush practise our fine lines by following the arrow directions and create strong clean thin lines. Fill out all the grey boxes and trace over the doodle examples continuing to fill the box completely.

zig zag

fill this box with doodles and trace over examples

lines from centre to outer ring.

write your name

lines to outer ring to centre

lines from centre out

Now you have practiced and those fine lines are thin, clean, and crisp; lets create some lace. Lace can become very complicated with the interwoven threads. To recreate it exactly on a nail could, if not done well, look very messy. So if you're hand painting lace, then you need to be clever. Take this example, using the whole design on a small nail would not be as effective as editing it down to a single element. Can you see where I have taken a portion of the lace detail and added it to the nail. I have twisted the lace so it sits nicely.

Before we go onto the lace nail art, lets practice this. Using the next three examples, copy out a portion of the detail in the example onto the nail shape.
There are three rules you need to remember;

1. KISS the nail, keep it nice and simple, just take a small part and recreate, don't try and get all the detail in.

2. You can edit. Removing some elements of a design so it works on the nail is allowed.

3. Try and place lace over a section of the nail, filling every nail might look busy and overcomplicated.

WORKSHEET

Taking just a small part of each lace example and create a nail design over the tips.
keep this as a repeat pattern over either the free edge or cuticle area.

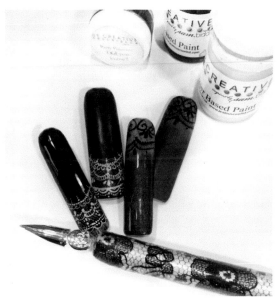

If you have completed the work-sheet, then this step by step will be easy. I have simplified the lace design and applied it over a gel polish. Now that you have drawn the steps, you can see how to break it down in each design and recre-ate one of them on a nail.

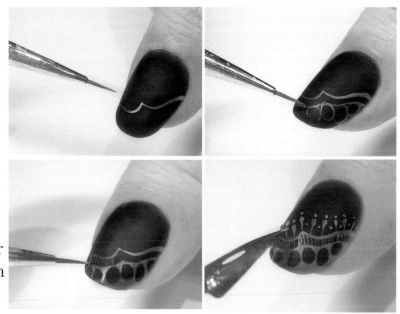

I tend to start with a boarder, this is my guide line, and then add the elements like circles or loops. Either applying lines or criss-crossing them will give you a feel for the delicate nature of lace, and with a few dots and tear drops, you have a basic template for your lace application.

There is a few other methods for applying lace, you could embed actual lace or stamp a design on the nail. Each of these fall outside the bracket of nail art, as they are an appli-cation which involves no art or creativity. However, they produce the end result of art and look lovely. They are definitely an option and certainly quick.

One final thing I want to say about lace; you have noticed I have not done full nails of lace. This is my preference and I like it over a portion of the nail. Look at these examples of lace around the cuticle.

Stickers & Stamping

This is one of those chapters where you wonder why it is in a book like this. This book is about nail art and design, about developing a style and building on nail art and design creativity. So why are we talking about stickers and stamping? As a purist you might think this is a form of nail art cheat, adding embellishments and patterns to a nail is nothing more than buying a pre made designed tip and applying it. But hold your horses - think about the variations and the possibilities. So yes, polishing a nail and adding a sticker in the middle and sending your client on their way is perhaps left for those uninspired, uncreative lesser mortals than us. But they are not reading this book, you are. So lets talk about how stickers and stamping can be used to create works or art, how to add to a design or even start off the creative process.

Stickers

So when I talk about stickers I really mean embellishments of any kind. Most of the time we are talking decals, either with a plastic sticky back or the water decals which slide off a backing paper when you stack them in water. Lets, for the sake of my sanity, ignore those pictures of cupids, bows, guitars, and anything which shouldn't or couldn't be placed within an actual overall design, shall we. You need to focus on designs which will enhance the shape of the nail and is able to be placed on different parts of the nail so it becomes part of an overall design. That includes the back ground and any added art you might add with a nail art pen or brush.
 Lets think about the possibilities;

 1. Create a baby boomer french ombre with pigments, add a base coat to protect this back ground and then place a beautiful, white lace effect decal over the nail so it blends into the white. Now you have created a nail using a sticker which works with the background.

 2. Using the water marble effect with paint and water, create a soft finish to the surface of the nail. Add a decal or sticker of a silhouette of a city over the free edge. Yes there you have a quick and very clever use of stickers over a stunning black ground.

3. If you feel compelled to use a sticker or decal with a pictorial element, then make sure you add it to the edge of your nail and incorporate it into a design. I am talking about those festive & holiday stickers with pumpkins and snow men, or a random rainbow. Even animals make me shudder when they have no connection to the rest of nail design. But this a matter of taste, and yep you do get some clients with absolutely none! So if you are put in a position where you have to use one, make sure it is at least in keeping with the back ground, or please add something else so your nails tell a story.

Create your own Stickers

Now you can create your own stickers - this gives you more control over what you want, you can include your own style and enjoy the creative process without the time restrictions of your clients.

There is a tool available where it is shaped with the same C curve as your nail, so if you were to make gel or acrylic embellishments it will just peel off and sit neatly on the natural nail service. The Arabella forms, when they where first introduced to the industry, were mainly for acrylic, but with gel polish being the preferred application for most nail techs, it works just as well using this. The material the forms are made of is literally non stick, so you can hand paint intricate works of art, and at a later date apply over a set of nails.

WHY? I hear you ask. Well it can save you time, you can practise without the client, and you can plan and prep a look. It is also great to do something complicated on your own nails, I am not ashamed to say, my right hand never looked better, as I quite easily applied my design, using my dominant hand on the forms and peeled and applied them when I was done.

So there are some simple rules to bare in mind. Of course, if you want to avoid the mistakes take heed of the advice before you.

The Arabella forms have a C Curve, so where you place or draw your design will be where it sits on the natural nail. Can you see where the flowers sit on the side of the c Curve? I have placed them there so when it is applied to the nail it will sit along the side wall. The gentle curve will mirror the curve of my nails. If I had done this on a flat surface, it would sit flat on the nail and I would have edges sticking out of the top coat.

I am using gel paint to create these, but you could use gel polish too. Gel paint is a gel which doesn't self level and keeps its form, gel polish would be better as an overall pattern or surface design, like marbling or an ombre.

You can hand paint onto the Arabella forms as well, taking a small area where the sticker will be placed and applying base coat directly onto the form. Cure this and dry wipe the surface. Now you have a smooth area to paint. if it is too shiny for you, then you could use a matt top coat instead.

It is not just stickers you can create, the Arabella forms are a perfect tool for embellishments too, made from Acrylic. Here is a step by step to create a Bow, when it is dry peel off and attach to the surface of the nail with glue. You can either encapsulate it with gel or acrylic or leave it on the surface as a 3D design.

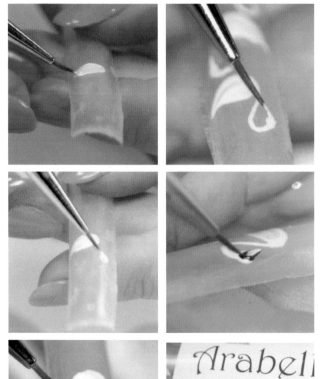

The Arabella forms have many uses and the main one is to create off the nail for use later. But I use them as a starting point for fantasy design as well - that is a whole other book right there. You can get the Arabella forms at www.sambiddle.co.uk

1. With white gel paint apply an oval shape onto your Arabella forms.
2. Add a smaller bead for the head above the body with some more white gel paint, extend the neck into an 'S'. Cure at this stage.
3. Pull out the beak from the head, make sure this is facing down towards the body.
4. With yellow gel paint, colour the beak in.
5. Add black gel paint around the yellow to create the eyes and head area.
6. Continue adding more swans and fill your Arabella forms to apply to your nails later. Cover the swans with a small amount of gel polish top coat and cure.

To apply these stickers to your nails, peel them off and secure with gel polish top coat.

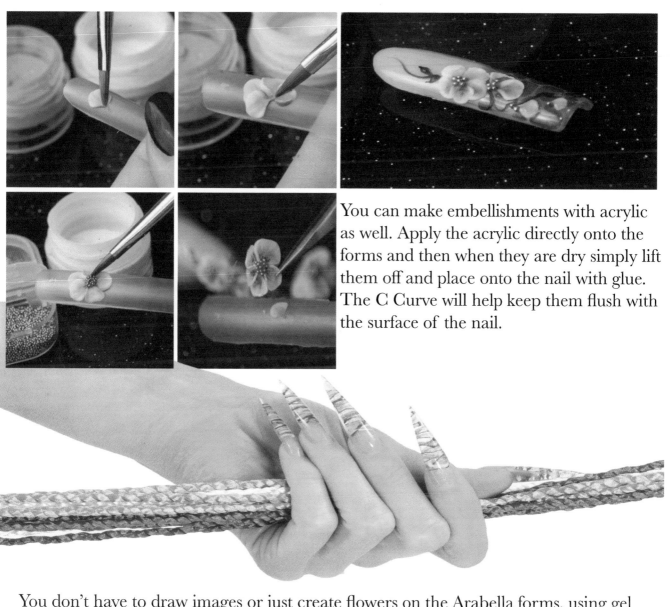

You can make embellishments with acrylic as well. Apply the acrylic directly onto the forms and then when they are dry simply lift them off and place onto the nail with glue. The C Curve will help keep them flush with the surface of the nail.

You don't have to draw images or just create flowers on the Arabella forms, using gel paint and drizzling this over the form, curing each coloured layer individually gives an almost 3D quality once embedded into gel. It looks like strands of thread in the tip of the nail. All you have to do is make sure the gel is thin and you layer the white between each colour. Then trim the gel ripples and embed them into the gel.

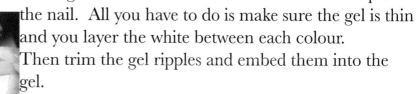

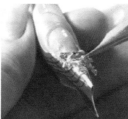
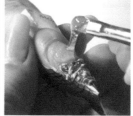

Hot Lips

This is one of those iconic designs which look fantastic on a set of nails, making it perfect for the salon, I could not resisit including these in the book, especially as they can all be pre made before the client even walks through the door.

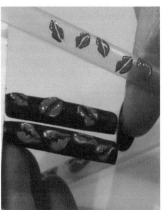

Apply 2 coats of your gel polish, I am using black here, but these lips over a red gel pol-ish would rock and maybe try some hot pink lips over a nude.

You're going to need red, white and black acrylic paint, and to start with we will be placing our basic shape done in white. This will real-ly make the red pop plus give you a clearer view of the shape you're going to need. Start with creating a small moustache shape.

Now apply the lower lip in white and make sure it is full, there is nothing more sexy than a plump lip.

When the white lips are dry go over them in the colour of your choice I am using red here.

For the detail, simply use black paint (or the same colour as the back ground gel polish) and refine the shape and add the detail to the lips, the fine lines curving out from the open mouth will give the lips a more realistic look. Make the lips longer in the centre of the bot-tom lip to have it appear fuller.

Finally for the highlight and this is what gives us that iconic Pop art feel. A bright white stroke on the upper and lower lip will have your lips looking glossy and full.

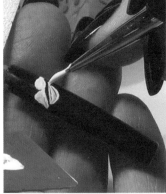

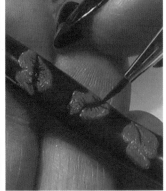

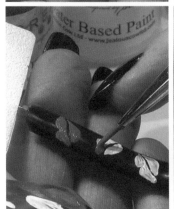

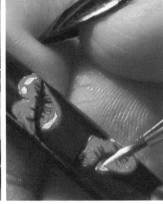

Stamping

I have to be honest here - it is confession time. When stamping first turned up on the nail art scene I was not impressed. Why would I do this when I am quite capable of doing art with a brush or a pen? But then I was sent some to try. After some practise, I realised this had potential, not to replace nail art but enhance it. It is not my first thought when I do nail art, but if I am in a hurry, or have a design idea which is new to me I use the stamps as a template.

Over a background like the pigment ombre or a marble the stamping can become part of an over all look and not look like it is placed onto a colour randomly. You can use it over a free edge design or full cover. The best bit, you can the use lines that the stamp pattern has created and colour them in, or add additional detailing to it, to make it your own.

I am not going to spend a lot of time talking to you about stamping and stickers, that is a whole other book, which might get written one day. But let me leave you with this final thought and, of course, a step by step.

In modelling they say don't let the outfit wear you, you have to wear the outfit.

The same I think applies with stamping. Stamping should be a tool you as a nail artist can use to enhance your creativity, it should not and never be a solution and end result.

Look at the areas which can be added to, by blocking out with a solid colour or adding extra patterns, lines or dots. You're using the 'guide' lines of the stamp to help you with your design.

Step 1; Polish the nails with a base colour…for the Brights I love using white.

You can use regular polish or for these I find it easier to use gel polish.

Step 2; Now have fun with the pigments pressing them into the sticky payer. I have created a rainbow effect here. Now for the clever bit, apply base coat over this layer and cure. You will then need to wipe this layer with a dry brush or cleanser.

Step 3; stamping couldn't be easier…for speed I use polish over the design I want, roll the stamper to pull off the thin polish and then roll onto the nail.
Finally apply your top coat as usual.

Getting Dotty about Stripes

I nearly didn't put this into the book because I thought it was a basic application and that you would have covered this already in most nail art education. But there seems to have been a secret underground movement to bring this art form back and I am seeing many different ways to use them in nail art today. Dots & stripes are both, in themselves, great assets to include in your art work, so let me share with you a couple of great ways to make them stand out from the crowd.

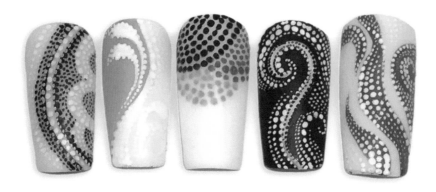

Dots Rule

1. Flower designs are never complete without a few tiny dots in the corner somewhere. I shall repeat some of that sentence; 'FEW TINY DOTS'. So when I say few and tiny that is what I mean. applying dots to a stunning flower arrangement on your nails should not become the focal point. You can make or break this design, believe me I have seen it. Here are two examples of how your dots can ruin a look:

Dots in a line make the arrangement less natural. On floral nail art dots represent the tiny buds or gypsum you get in floral arrangements. A line of dots belong in a more abstract design.

To many dots and the roses are overwhelmed, this looks like black fly has descended on the rose bush. Dots should be subtle, don't over work the area with dots.

There are enough Dots on here to suggest whispers of buds and foilage, but it does not detract from the rose which should be centre stage.

2. Use dots and colour to create an Ombre is genius, changing the colour and size of your dots to fade out into the background colour is a perfect way to use this simple idea of adding paint or polish to a nail with a small pointy tool. I know right, it is the simple things. You must make sure that the size of dots are similar, unless you're creating an abstract pattern. It is all about the size and placement with dots. That is of course if you want to lift this art form into the 21st century. Keeping your dots one size and changing the colour works, or blend out to smaller dots and a lighter shade of the same colour will also work.

Here are a few examples of what you could achieve with some dot determination.

- Same colour different shade ombre and change the dot size to blend out the colour as well.
- Multi coloured Ombre, using a combination of Hues over the free edge and vary the size as they travel up the nail.
- Baby boomer Ombre, from a white free edge, fading out with smaller dots towards the pink on the nail bed.

3. Abstract patterns work well on nails, but have you thought about ditching the brush and using dots instead? Instead of a random dot application as before, we can use the dot shape and size, add a colour contrast for impact and you have a wonderful effect. Using these three examples draw out a design, thinking about shape. I would recommend

sticking with either black or white for your dots and adding a bright colourful contrast. It is important to plan out a design like this, so you know where your dots should be and the pattern of the design.

Sexy Stripes

This leads me nicely into stripes. There is definitely power behind a nice clean stripe, either painted on or created by removing tape and revealing what's underneath. You can use stripes in pretty much any design and they can be straight or curved. There is just one rule; to be effective they should be the same width all the way along. Well perhaps not so much a rule, but a guide because of course you can have a tapered stripe. Just like dots, they should be seen and not heard. They are what forms the bases of your design but it is the other elements like the dots in the previous set of images which take centre stage. If you use striping tape to create a negative space, then it is the space you are revealing which should take centre stage. If the lines have to be clean, sharp and crisp, and the lines the same width all the way along, you're going to need a steady hand or an awesome technique.

One awesome technique coming up;

Striping brushes. I hear you shuddering, yes those long bristles can become your friend. Please do not pick up this brush if you want to create some fine detailing with small short strokes. These brushes are designed to carry the paint in a long straight line, and yes there is a secret to it.

It is all about the angle. Remember in the previous section we spoke about the angle of the detailer brush needs to be set at 90°? Well it is different for the striper. After you have completely coated all the bristles with paint, so they can hold enough paint to keep your line long and solid with colour, then you angle the brush so it is more horizontal to the surface. This way you can drag the brush without lifting or pressing and hey presto, the line width will remain the same.

Another key factor
in this application; the product you're applying. I personally always do it with paint, my
paint is highly concentrated with pigment and when I water it down slightly it maintains it's
opaqueness. It is ideal to have a viscosity which is thin enough so your paint is drawn easily
off your brush - too thick and it will not create a thin crisp edge.
You can use gel polish and polish of course, but again make sure it is not too thick, you
won't get a smooth 'drag' with the application.

Striping tape is another option, where you remove it or leave it under a top coat to create
fine lines. I have to admit I get very impatient with tape, as it is very fiddly so find it quicker
to pull out a brush and use paint. However if I want to reveal a beautiful pigment ombre
or marble design, or edge my negative space nails with a silver hologram, then tape is what
you use.

Remove & Reveal Technique

We are going to keep it simple here and I would like to share with you how to use tape to
create a stunning effect, just by revealing the colours underneath.

Top tips when it comes to striping tape?

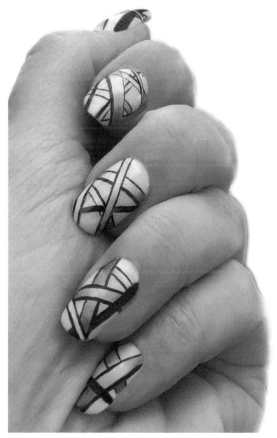

When removing the tape to reveal, I would always use
regular polish. Applying tape and using a gel polish,
curing and then pulling it off doesn't have that effect
of a clean crisp line.

Get a striping tape dispenser - trust me, it is just like
cellotape or scotch tape dispenser but for thin tape -
but very easy when trying to cut and stick.

Use scotch tape or cello tape instead - maybe you
want to create a sharp edge to a design and just want
to block out the background so it doesn't get covered
with colour or pigment. Check out the following steps
to create this look.

To create these nails apply a base coat and a white gel polish. Cure both layers of colour.

I have created these stripes by adding a small amount of sticky tape over the gel polish, and then patted the pigment as a blend, starting with the light yellow in the centre, working out to orange and then using pink. (I have used this low tack tape, but you would find success with cello-tape. It must cover the whole nail to avoid pigment getting where you don't want it to get.

Peeling the tape away is very satisfactory when the pattern is revealed. It is important you use a low tack tape like this one, so you don't end up pulling away any pigment as well.

Re apply your tape to reveal another line so it criss crosses over the first. As you can see in these steps I have crossed over them a few times. 3 or 4 per nail is enough.

Base coat your pigment lines and then use your striper brush to add detailing, thin and thick edges to this stripes. Top coat the nail when your happy.

The Special FX

So I can't ignore it any longer, there has to be a section in this book which covers those special effects we see on nails. I am not talking about glitter or gems, but those effects on the surface of the nail which makes you wonder 'how did they achieve that?' or 'is that a polish?"

What it basically means is all those things which are not a polish to create an effect over the nails. Generally this is not nail art, this is just an unusual effect that is worn on nails. I will try and keep my opinion out of this, I have tried them all, but I am an artist, and these applications are good to use on clients, but I feel like they shouldn't come under the heading of nail art.

They are nail effects and have no art in them at all. Don't get me wrong, they are stunning, effective and quite wonderful, but no skill is required unless they are teamed up with one of the art techniques.

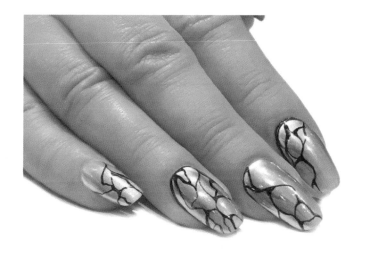

Chrome nails

As I write this book, it is application which has the industry talking, like marmite it is a love hate look, but you have to try it anyway. although the industry seems to be seeing this for the first time, it is by no means a NEW look or even a new application technique. But like everything viral, it has been carried away with enthusiasm and great marketing. The sad thing is the cost, as a trend grows so does the price tag.

Chrome nails is a pigment applied to the nail surface which has a high content of aluminium, a metal which gives a very high shine. Now, most pigments with this metal in it will give you the effect, and I have had pigments in my product range for the last six years. However it is the application of the pigment which is new. Instead of using the inhibition layer and having the powder stick to it, you are using a no cleanse top cot, this is important, as you don't want any residue from the cleanser on the surface of the nail, plus you don't want a top coat which seals, it has to be slightly porous. Now you get your pigment and rub it into the topcoat once it has cooled, until you get your shine or mirrored effect. I have used many tools, but a make up application with a sponge end works well, I have used just a sponge and my finger covered in a latex glove. No where is the secret, depending on the top coat will determine the level of Chrome effect you get. The no cleanse top coats seem to work the best.

Mirror nails

The mirror nail effect, or even shattered glass look is usually foil, wrap or polymer film with either a reflective surface or iridescent shine to it, cut it into small shapes, ideally triangular and embed it into your gel. Gel works best as it magnifies the surface of the film and gives it a mesmerising quality as you turn the fingers.

Cats Eye Design

As I write this the latest obsession is the new cat eye gel polish, we have seen the magnetic gel polish before, but the most recent additions give you an amazing cat eye gemstone effect that shifts with movement. Quite mesmerising; you can either get the gel polish as a colour or top coat. I have only used the top coat, and you do need to apply a lot to get a good effect. It works best over a darker colour. Watch in wonder as you tilt your finger tips. The secret of this manicure is in the magnetic properties of the gel varnish. These special micro-particles, when under the influence of a magnet, collected together into a pattern. To get such a beauty, not necessarily having to go to an expensive salon. You could potentially use any magnet, using a small pen type magnet is a great way of controlling where the particles go.

Frosted Glass

I love this technique and it is not new, I did this 10 years ago and recently saw it had revived. It is new and improved and I think, although fiddly and takes a lot longer than a regular application, can look very effective. Of course I could not let another opportunity to share with you my step by step of these frosted glass nails.

It is sometimes the most simple ideas that make the most impact. This is not an application that most people think to do when they think about nail art and design, but wow it does produce a cooler than cool look on the free edges. You will have to stay with me throughout this step by step, even if is sounds ridiculous, trust me, it will look amazing and not take too long to achieve stunning results.

Before you do anything, prepare the sculpting forms. This effect can only be achieved using sculpting forms. Stick a small piece of double sided tape to the top of your form.

Apply your forms to the natural nail, after you have prepped them. And then peel away the protective layer of the tape, so the top side is also sticky.

To get the crushed ice effect we will be using silver foil. You can use foil and create any type of pattern in it.

Don't press all the creases out with your finger, try and keep it as crinkled as possible but at the same time flat. I use the tips of my scissors to dent the foil.

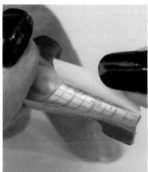
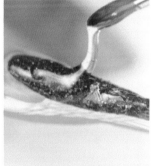

Now for some magic. Use KY gel, or any type of water soluble lubricant. This will help when you come to remove the foil from the underside of the nail. Apply a thin coat of lube with a brush.

I have used Colour drops and mixed about 4-6 drops into some clear hard gel, this will give me a clear stained glass effect. The different shades of red sit in the grooves of the foil and make it really pretty.

Apply this red gel over the free edge, on top of the foil and continue the application over the nail bed as well. I have added glitter to the gel mix to apply over the nail bed. Curing each stage, cap the whole nail in clear gel

Remove the form and your foil should pull away from the underside of the nail. You may need to use tweezers if you have not applied enough KY gel. Now your ready to file and re-fine the shape of the nail, and top coat the nail.

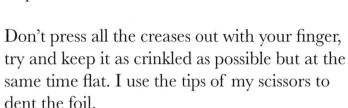

Foil, Wraps and Minx

The question I get asked time and time again is, 'how do I get my foil to stick, they are not working'. I have not made it a secret that this is my least favourite effect. I like the application if it is just the foil, but when the foiling is used to enhance perfectly great art work, then I get frustrated. It is a style which is not mine, but preferred by many, so who am I to judge?

But let me answer that question of why it won't stick. Knowing how long to leave the gel in the lamp for optimum stickiness is the key to getting your foil to work and here is how I test mine.

You will need; tip lamp, black & white gel polish, base coat, top coat, pen and paper and foil.

IMPORTANT STUFF YOU NEED TO KNOW;

The colour of your gel polish will make a difference. White and light gel polish will leave less of an inhibition layer than the darker colours, that means less stick sooner.

The longer the gel is in the lamp, the less inhibition layer is available to you, that means less stick. (this works for pigments too)

Just incase you're wondering, the inhibition layer is that sticky layer that is left when the gel comes out of the lamp, it is the uncured layer of gel because Oxygen has prevented a full and proper surface cure.

If you cure the nail and then leave it, say you're curing a full hand and work on one nail at a time, by the time you get to nail 5 there will be less stick. The gel will sill cure in day light away from the lamp. So follow these quick steps to find out how long your gel polish needs to be under your lamp for that optimum stick ability.

- Apply two coats of colour on a long tip.
- Now cure for 30 sec & then apply the foil, in the first section
- Cure for 60 seconds and then apply foil in a different section above the first on the same nail
- Finally Cure for 90 seconds and do the same. (if you want you can go for a full 2 mins, but i suspect you don't need to)
- Look at the way the foil adheres to the nail and choose the one you like the most – is it 30, 60 or 90 second cure.

If your still using UV, then you need to reduce your initial cure times from 2 mins to 30 secs, 60 seconds and so forth. UV will reduce the stick - remember the rule: the longer in the lamp the less stick.

REMEMBER your results will change with the colour, lamp and gel polish you're using. So use your pen and paper and record your results. Trust me you will forget in a couple of months when you decide to switch gel polish on a client and the foil application just doesn't stick. Another thing you could try; apply top coat and base coat and check out your results, don't forget to test gel paints as well, Gel paints leave less of an inhibition layer than gel polish, so the times might vary.

Still doesn't work….try these Top tips

Foil Glue; I confess when I started using foils way back then (yes that long ago) there was no gel polish, topcoats or gel paints, In fact there was no gel! I used to apply my foil on regular polish or acrylics and I used foil glue. I still do to be totally honest with you. It gives me the very best results. You simply paint it on, leave to go clear and then apply foil and tear away.

I have never done this, but if you're still not getting results try applying a little acetone on a cotton bud and turn the foil over and quickly go over the back to remove the matte layer and they will transfer better.

I find the silver backed foils work better for me than the brownish ones, however with foil glue, there is never an issue.

Try using a cotton bud to press your foil on the nail instead of your finger, it might give you better results.

It's a Wrap

Wraps, or otherwise known as Minx, are still popular, especially for toes. It is a high performance vinyl film product designed to cover the nail plate. Heat is applied to the individual wraps that activates the adhesive on the underside of the wraps and allows you to stretch the wrap for that perfect fit. You don't need gel or acrylic, polish or gel polish. These are simply applied directly to the nail plate and the free edge is sealed over with the wrap. Or you could use nail glue for extra peace of mind. I mention them, because they are not just an alternative to colour but normally have some wonderful images, patterns and effects on them, nail my holographic, which is my favourite and not something I would draw on. They are a very quick alternative to instant nail art and not a big investment.

IT IS NEVER THE END

That is the one great thing about art, there can never be an end, as we paint, create or even perform we are releasing something and because we are letting it all out, we have room for new ideas and new inspiration. The next project is playing out as you're finishing your works of art, how delightful is that.

The very same is happening with this book and me, there are so many things I wanted to include in this book, but apparently it has to end otherwise it will be bigger than the bible. I have left you with everything you need to know about nail art and nail design to get you started. Just remember what I said in Chapter 1, my nail friend Creativity takes practice and you must make a habit of using it.

Although this book might differ to anything you have read about nail art, it should be a useful tool to you. I encourage you to fill out your work sheets, and complete the exercises, I would go as far as to fill this book with notes and doodles.

It is mandatory to share your works of art with me on social media of course, I would love to see your results; you can find a list at the end of this chapter.

So it is time for us to say goodbye. If you managed to reach this far in the book, congratulations! You should be well on your way to being a confident and self assured nail artist. Own your skills, develop your style and don't, what ever you do, listen to that miserable voice in your head telling you all sorts of lies about what you can or can't achieve.

I know you can do it...well lets face it, if I managed it, then there is hope for you!

Social media address's

Be Inspired Facebook page - https://www.facebook.com/beinspired.sambiddle/
Be Creative Facebook page- https://www.facebook.com/becreativeworldwide/
Twitter - https://twitter.com/sambiddle
Linkedin - https://uk.linkedin.com/in/sam-biddle-a5362123
You Tube - Be Inspired - https://www.youtube.com/user/sambiddle1
You Tube - Be Creative - https://www.youtube.com/becreativeworldwide
Pinterest - https://uk.pinterest.com/samsinspired/
Instagram - https://www.instagram.com/sambiddle_inspired/?hl=en

Pigments and other cool Stuff!

You might have noticed I have used a lot of items in the step by step from my own company Be Creative, well, why wouldn't I. You can find them all here on my website www.sambiddle.co.uk

Online education and face to face learning!

Yep there is a whole heap more you can learn, and I have made it very easy for you too. You can come on a course and spend time with me, or if that is not an option why not sign up for my rather unique and very awesome online course. you can find more information at www.sambiddle.onlne

My notes

Printed in Great Britain
by Amazon